Contemporary Studio Case Furniture

Contemporary Studio Case Furniture: The Inside Story

Essays by Virginia T. Boyd and Glenn Adamson
Introduction by Thomas Loeser

Organized by Russell Panczenko

Elvehjem Museum of Art
University of Wisconsin–Madison

2002

This book is published on the occasion of the exhibition
Contemporary Studio Case Furniture: The Inside Story
at the Elvehjem Museum of Art
University of Wisconsin–Madison
April 6–June 16, 2002

Russell Panczenko, exhibition organizer
Virginia T. Boyd and Thomas Loeser, cocurators

Published in the United States by the Elvehjem Museum of Art,
University of Wisconsin–Madison, 800 University Avenue, Madison,
WI 53706-1479

Library of Congress Cataloguing-in-Publication Data

Boyd, Virginia T.
 Contemporary studio case furniture : the inside story /
essays by Virginia T. Boyd and Glenn Adamson ;
 introduction by Thomas Loeser.
 p. cm.
 Exhibit held at the Elvehjem Museum of Art, University
of Wisconsin-Madison, April 6–June 16, 2002.
 Includes index.
 ISBN 0-932900-77-1
 1. Case goods–United States–History–20th century–
Exhibitions. I. Adamson, Glenn. II. Elevehjem Museum of Art.
III. Title.

 NK2712.3 .B69 2001
 749.213'074'77583–dc21

 2001058567

Cover: Jere Osgood, *Summer 99 Shell Desk*; Wendy Wiesner, *Caged*; Emi
Ozawa, *Seesaw 2, Four Quarters, Pendulum Box, Quack-Quack, Half Moon*;
Tom Loeser, *Roller #1*; Jim Rose, *No. 99 One-Door Cupboard*; Garry Knox
Bennett, *Black Buffet*.

Back cover: Brian Wilson, *Keeper of Memories*; Bob Trotman, *White Guy*;
Gayle Marie Weitz, *Persona # 9: Teenager* from the series Social Studies.

Details from other artists' work: page 1, Kristina Madsen, *Cabinet on
Stand*; page 2, Jenna Goldberg, *Entry Cabinet*; page 4, J. M. Syron and
Bonnie Bishoff, *Ilseboro Series: Small Chest*; page 96, Judy McKie, *Ribbon
Cabinet*.

Table of Contents

Foreword

Russell Panczenko

Modern art museums throughout the United States generally have distinguished the decorative arts from the fine arts. Art works categorized as decorative are relegated to separate galleries and even to entirely separate museums. Where the line of demarcation falls between the two, however, was and is far from clear.

In the western world, the division between the fine arts and the decorative had its beginnings in the fifteenth century when Europe's leading painters and sculptors added to their already extensive technical virtuosity the connoisseurship of classical antiquities, the theory and practice of mathematical perspective, and the knowledge of human anatomy. Patrons of the time considered that the new intellectual basis of their art raised them above those who continued to make fine decorative and functional objects for both church and palace.

The elevation of painting and sculpture reached its zenith in the eighteenth century. Throughout Europe, academies were created to provide the intellectual preparation required of the artists of the time. According to Sir Joshua Reynolds, president of the Royal Academy in London from 1768 to 1792, "The value and rank of every art is in proportion to the mental labor employed in it, or the mental pleasure produced by it. As this principle is observed or neglected, our profession becomes either a liberal art or a mechanical trade." The decorative arts were left behind; its practitioners continued to prepare through the older workshop system of apprenticeship.

During the nineteenth century, the machine-manufactured products of the Industrial Revolution further distanced the fine arts from the decorative. Not only did the latter lack intellectual content or fail to elicit intellectual response, but now they were mostly manufactured en mass by machines, devoid of the fine personalized craftsmanship of an earlier age, a personalized craftsmanship that the fine arts still fully espoused.

Although the arts and crafts movements, which sprang up in Europe and the United States at the end of the nineteenth and the early twentieth centuries, restored artistic dignity to hand-made decorative arts, they were quickly overwhelmed by the intellectual ferment and social activism of early twentieth-century modernism. Besides, beautiful, unique objects were of necessity expensive and therefore morally suspect in an era that prized egalitarianism and uniform standards of living above individualism and luxury. Also, starting early in the twentieth century many avant-garde painters and sculptors themselves rejected fine craftsmanship in their work. Some turned to machines as the only appropriate means for making art; others turned to found objects; still others insisted that the only value of the fine arts lay in automatic psychological expression or the intellectual concept itself. Craftsmanship, as far as the curators, critics, and practitioners of the fine arts were concerned, was considered irrelevant, and "crafts," i.e., the decorative arts where fine craftsmanship still reigned supreme, were largely ignored.

In recent years, the presumption that craft is to be kept separate from the fine arts is coming under scrutiny. Joshua Reynolds's two criteria of requiring mental labor in the creation of the objects and of giving mental pleasure to the viewer have certainly been met at least in the realm of contemporary studio furniture. And in a period when minimalist ideas and formalism are beginning to seem repetitive and simply not enough to satisfy either the mind or the eye, the craftsmanship of the studio furniture amazes and delights both. This changing attitude toward the decorative arts is marked in the Department of Art History at the UW–Madison by a new chair in American decorative arts. At the Elvehjem the exhibition *Contemporary Studio Case Furniture: The Inside Story* represents an acceptance that studio furniture belongs in its galleries.

Once we made the decision to present an exhibition of studio furniture at the Elvehjem, our question

was how to go about it. One of the major advantages of university museums is the immense wealth of knowledge and expertise that is readily available in the parent organization. We were fortunate in the presence on the UW–Madison faculty of Tom Loeser, a highly acclaimed studio furnituremaker and associate professor in the Department of Art, and Virginia (Terry) Boyd, professor in the Department of Environment, Textiles and Design, whose scholarly work in all aspects of design is highly respected. The idea of an exhibition shaped by both an artist and a scholar had great appeal from the museum's perspective, and I am grateful to both of my colleagues for responding so enthusiastically to my invitation and bringing the project to such wonderful fruition. Based on Tom's recommendations, we solicited and reviewed several hundred slides and developed a conceptual framework for the exhibition. Our enthusiasm for the materials we received grew to such an extent that we could not bring our selves to select the small number that made an exhibition logistically feasible. To break the impasse, we invited Edward S. Cooke Jr., Charles Montgomery Professor in the Department of History of Art at Yale University, to Madison. We are grateful to Ned for his invaluable insights and for the excellent suggestion that case furniture be the focus of the exhibition.

We have many people to thank for contributing to the successful realization of *Contemporary Studio Case Furniture: The Inside Story*. We warmly thank Glenn Adamson, the recently appointed curator of the Chipstone Foundation and adjunct lecturer in the Department of Art History at UW–Madison, for his excellent essay locating contemporary studio furniture in a broader historical context. Among the members of the museum I wish to acknowledge the efforts of my assistant Lori DeMeuse, who efficiently organized communications between the artists and the curators, and created a model database for the management of all the slides. She was preceded by Lynne Thiele, who played an effective role in the early stages of the project. We specially thank our editor Patricia Powell, who diligently worked with authors, artists, and catalogue designer David Alcorn to keep the publication on schedule and of high quality. Associate registrar Jennifer Stofflet made efficient arrangements for complex crating and shipping of the works in the exhibition. Development specialist Kathy Paul expertly and sensitively helped to identify the funds for the exhibition, while our exhibition designer Jerl Richmond and preparator Steve Johanowicz created the gallery environment best able to show off each individual work. I'm grateful to all the Elvehjem staff for their extra efforts in bringing this exhibition to the public.

In an exhibition of this scope, with work coming from all over the U.S. and Canada and Australia, we are beholden to many private collectors who were willing to provide us with works from their homes as well as public collectors and galleries. In addition to artists who lent their own work we want to thank both the anonymous and the following acknowledged lenders to the exhibition: Anne and Ronald Abramson, Beverly Barfield, Gail M. and Bob Brown, Sally and Jose Diaz, Stephen E. Dubin and Mary Chin, Diane and Marc Grainer, Robert and Gayle Greenhill, Sheila and Eugene Heller, Tom and Diane Heyrman, Wendy Evans Joseph, Mr. and Mrs. Jerome A. Kaplan, Marena C. Kehl, Dr. Eli and Judith Lippman, Victor and Faye Morgenstern, Museum of Art of the Rhode Island School of Design, Helen Hilton Raiser, The Saskatchewan Arts Board Permanent Collection, Douglas A. Simay, Dr. Kirby and Pricilla Smith, and Stephen and Susan Weber.

We would have never been able to present this marvelous studio furniture without the generous assistance of the following sponsors: Pleasant T. Rowland Foundation, Hilldale Fund, National Endowment for the Arts, a federal agency, Anonymous Fund, Brittingham Fund, Techline and Marshall Erdman and Associates, Anne and Ronald Abramson, and Dane County Cultural Affairs Commission with additional funds from the Madison Community Foundation and the Overture Foundation. I am very grateful to them for their confidence in the museum and their support of this project.

Finally, I must thank the thirty-seven artists who participated in this exhibition for their cooperation and their patience, for this exhibition was several years in the making. We are truly honored to be able to present the work of each and every one of them in the Elvehjem Museum of Art.

Russell Panczenko is director of the Elvehjem Museum of Art and organizer of this exhibition.

The Inside Story on Studio Furniture

Tom Loeser

The objects in this exhibition are an unusual hybrid. They combine an interest in issues of functionality with an expressive creative process that presented as functional solutions to human needs, yet they often ask a lot of the person who intends to use them. In other words, they are rarely the most straightforward solution to a given functional need. Many pieces included in this show are formally exquisite objects, which are also awesome displays of technical prowess. However, these pieces cannot be fully understood without an intellectual engagement with the ideas and intent of the maker. They are made one at a time in small workshops and studios, usually by the maker working alone or with a small number of assistants. The object-maker has total control over the creative process. I suspect that in many cases this ability to be in charge of the making process from beginning to end is one of the things that attracted these makers to the field of studio furniture.

Although a few of the makers in this show are self-taught, the majority got their start through some sort of formal training in the craft of furnituremaking. Apprenticeships occasionally still play a role in the education of studio furnituremakers; a stint as a paid employee in the shop of a well-established furnituremaker is more common. However, the most frequent educational route for aspiring studio furnituremakers is the small number of college and university programs in this country and abroad that offers training in the techniques, aesthetics, and concepts of furniture design and making. These educational institutions offer both technical training in the craft of furnituremaking and visual training in the aesthetics of design. However, the most important result of the central role of college and university programs is an increased focus on the concept or idea inherent in the studio furniture object.

My own path to becoming a furnituremaker may shed some light on this issue. After I graduated from college with a liberal arts education in sociology and anthropology, I had absolutely no idea what I wanted to do. For some reason I made the lucky decision to enroll in a serious woodworking course. I was instantly hooked. I found the challenge of learning the many technical details of furnituremaking to be intoxicating. I spent long hours cutting joints, tuning tools, and trading information with classmates. I ended up spending the next several years in a university program, loving every minute of it, and concentrating in a way that I had studiously avoided in my previous studies. Although I was oblivious of it at the time (thinking I was just learning a set of technical skills to make furniture), an entirely different educational transformation took place primarily through the group critique that we used to look at, discuss, and evaluate finished work. In these critiques we were discouraged from talking about technical issues. Instead we struggled (myself more than anyone) to address what was successful and unsuccessful in the work. What made some objects sing while others sank? More and more I found that the objects that made my heart beat faster embodied the individual voice of the maker. It was tremendously exciting and challenging to discover that furniture had this sort of expressive potential. It also meant that sheer technical virtuosity and appealing proportions were no longer enough. The best work represented a creative vision and engaged in a dialogue with the viewer/user.

I think it is relevant to mention that this concept of work with a voice was a key criterion that Virginia Boyd and I used as curators to select the work for this show. Each piece in its own way made our hearts beat faster.

As we reviewed visual materials from many different furnituremakers, I was especially impressed by the work of recent graduates from university programs. An interesting phenomenon is going on in some of the most prominent academic programs around the country. The student work no longer looks like the faculty members' work. Younger makers are creating work in many differ-

ent styles that will cause us to question, adjust, and ultimately broaden the studio furniture paradigm. When I used to look at a piece by a younger maker, I could usually tell at what school they studied and sometimes who they took summer workshops from. I'm only partially exaggerating for effect; it really was true. However, it doesn't work anymore. This is a very healthy sign of the vitality in the furnituremaking field. Younger makers are cross-pollinating with makers in other disciplines, making many previous real and imagined boundaries obsolete. Furniture students are deeply engaged in dialogue with fellow students and faculty in all areas of artistic creativity including sculpture, painting, printmaking, installation, and site-specific work. In many cases the only way to recognize work by a furniture student as opposed to work from the sculpture area is the continuing connection with ideas and issues of functionality.

In the end function is still the crucial identifying marker that distinguishes the pieces in this show from work that is pure sculpture. One result of the functional aspect is that furniture objects not only have a viewer, but also a user. There is a bit of a dilemma in mounting an exhibition of case pieces in a museum setting: Case pieces contain an inside story, an interior space that must be physically accessed by drawer, door, or lid. That space is crucial to the meaning of the piece, yet the "hands-off" museum environment prohibits that exploration. The process of coming to understand this work must include our best attempt at understanding what it would be like to interact with and use each piece. What is the physical process the viewer/user undertakes to reach the inside space? How does a piece change as the user manipulates doors, drawers, and lids?

Being an interactive user also allows one to engage other senses besides sight. What are the tactile qualities of handling the pieces? What are the sounds associated with opening and closing doors, drawers, and lids? These pieces contain empty inside spaces. The viewer/user/owner has an active role to play in choosing to fill or not to fill those spaces. If the choice is to use those spaces, what is the appropriate item(s) to put inside?

The fact that furniture engages the viewer/user not just visually and intellectually but also physically is certainly one of the reasons I was initially attracted to furnituremaking, and I suspect the same holds true for many of the other furnituremakers in this exhibition. What we make is accessible. It is not intimidating Art with a capital A. Instead, it is furniture with a small f, and people are comfortable around it. Interestingly, I think many of the most successful pieces in this show play with people's furniture expectations. In Bob Trotman's figurative piece *White Guy*, a drawer is not just a drawer; it is also a way to open up and have access to the interior state of mind of the person portrayed. *White Guy* works as a compelling visual image and an intellectually challenging piece because of its unexpected insertion of familiar function into a realistic figurative form usually not at all associated with furniture.

I want to return to the "hybrid" term I used at the beginning of this essay. As a collection, the hybrid objects in this exhibition offer a multifaceted analysis of the furniture object. The multiple points of view represented in a large survey show like this generate a pulling, pushing, and stretching of functionality that challenges the viewer/user's preconceived notions of what furniture should be. It is a dynamic dialogue, with the best pieces serving to open our eyes to new ideas, possibilities, and directions for furniture objects.

Tom Loeser is cocurator of this exhibition and associate professor in the Department of Art at UW–Madison.

Studio Furniture: The Last Ten Years

Glenn Adamson

No museum exhibition is without its assumptions, and the present one is no exception. In focusing on the theme of case furniture, this book and the show that it documents take several things for granted. First, they presume that there is a discrete category of objects called "case furniture," and that these are interrelated both in form and concept. Further, by focusing special attention on this category, they propose that the category of "case furniture" contains specific areas of content that are worthy of analysis—such as the tension between interior and exterior space, the status of the surface or "skin" of the piece, the physical dynamics of storing and retrieving, the value of secrecy, and ultimately, the way such furniture helps to organize our lives Thus, the objects in this exhibition are more than instances of case furniture; they also offer ideas about that category itself. *Contemporary Studio Case Furniture: The Inside Story*, then, is about a constellation of themes in which furniture participates, rather than a family of furniture forms. In this respect, it marks a new set of developments in studio furniture's short history.[1]

Any exhibition, of course, relies to a great extent on what precedes it. One of the more subtle underpinnings of this project is a tacit assumption that the category of case furniture is worthy of analysis because the genre extends backwards into decorative arts history. Furniture made today, that is, is meaningful because it is descended from counterparts made in colonial America and even in the ancient world. This may seem obvious enough, but, in fact, it was not until recently that the notion of this unbroken historical continuum was concretely established and accepted within the studio furniture field—by an exhibition that was, in many ways, the precursor of the current one. This was *New American Furniture: The Second Generation of Studio Furnituremakers* at the Museum of Fine Arts in Boston, organized in 1989 by the decorative arts historian Edward S. Cooke, Jr. Ambitious in its scale and concept and prominent because of its institutional backing, the show was—in the words of a contemporary observer— "the first survey to put studio furniture in the context of craft and art history."[2]

New American Furniture explicitly framed the work of contemporary makers within an overarching decorative arts narrative. Each object in the show was based upon an antique piece in the museum's collection— often borrowing forms from the antecedent with tongue in cheek. Despite the light-heartedness of some of the resulting works, a good deal was riding on this curatorial exercise of pitting the new against the old. The strategy emphasized the notion that contemporary makers are the rightful inheri-

tors of the great tradition of American furniture. In the catalogue for the exhibition, Jonathan Fairbanks—the head of the museum's Department of American Decorative Arts and Sculpture at the time, and a longtime champion of contemporary craft—explained: "In the 1980s many studio furnituremakers have eagerly examined historic furniture, probed its meaning, and incorporated it within their personal vocabularies ... This seems like the right moment to analyze real rather than virtual connections between historic and contemporary works, and to celebrate the fresh new attitudes about design, its history and process, shared by contemporary furnituremakers in America."[3]

Within this historicist framework, Cooke's catalogue essay provided the intellectual equipment that was necessary for the extension of furniture history from its traditional terrain into the present. His genealogy divided the studio movement into two discrete generations.[4] The first was composed of pioneering craftsmen such as Wharton Esherick, George Nakashima, and Sam Maloof; the second included the self-consciously exploratory makers included in the exhibition. This binary structure mapped onto a historical progression, in which the first generation's concerns with "function and technique" were superseded by "functional work layered with evocative or metaphorical meaning."[5] In a sense, Cooke's history functioned as a chronological demarcation of a divide between traditional and avant-garde practice. He offered nuances in the contrast, however, by pointing to the diversity of the leading university programs in the medium and carefully tracing the lineages of students produced in these programs.

The history presented in *New American Furniture* was marked by the moment in which it was written—a moment when the emergence of the avant-garde chronicled by Cooke was in its most precipitous incline. To a large degree, in fact, Cooke's was only an unusually concrete and developed version of what many in the field had been saying throughout the 1980s, with increasing conviction. An explosive market for the crafts meant that the "second generation" makers had been able to explore their more adventurous ideas with confidence.[6] Museums played a small role in this period, but it was in the commercial arena that the greatest strides were made. Galleries such as Workbench in New York, Pritam & Eames in Easthampton, Snyderman Gallery in Philadelphia, and William Zimmer Gallery in Mendocino, California, all encouraged experimentation in woodworking by organizing thematic or monographic shows (figures 1, 2). The increasingly prominent craft fairs organized across the country by the American Craft

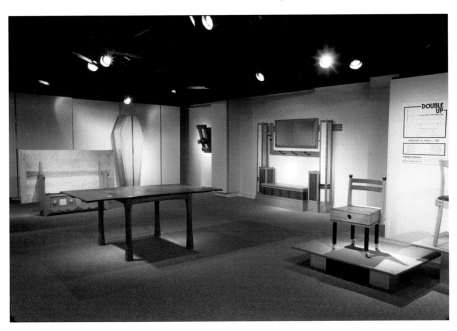

Figure 1. The exhibition *Double Up* was held at the Workbench Gallery in New York in 1987. The show featured furniture that incorporated multiple functions. Shown is furniture by (left to right): James Schriber, Robert Kopf, Stephen Whittlesley, Lorna Secrest, and Jeff Behnke. Photo by Craig Barndt

Council (ACC) also had an impact, in that they provided a consistent and high-profile venue for the exhibition of work to large audiences.[7] Coming at the apex of these heady years for studio craft, *New American Furniture* articulated a broad, undefined potential for the medium. It was very much of its time—when anything seemed possible, but nothing seemed inevitable.

It was at this crucial moment that Peter Joseph, a banker, lawyer, furniture collector, and philanthropist, made a sudden and controversial entrance into the marketplace Joseph had long been a patron of the arts, particularly of ballet and theatre in New York, and it was with an ambitious spirit and a deep emotional commitment to studio furniture and its makers that he approached the task of setting up a gallery. In the 1980s, Joseph had been exposed to studio furniture through Pritam & Eames Gallery, where he had bought pieces for his own collection. A business-minded man, he quickly sized up the problems in the field: it was difficult for makers to find the time and capital necessary to create a body of speculative work, and commissions, which provide a more reliable source of funds, can be limiting to creativity. Consequently, he began to provide financial backing and sponsorship for furnituremakers whom he thought worthy of support. He engaged Lorry Dudley, an experienced gallery manager from Texas who had worked for a time in Wendell Castle's studio, to assist him in these efforts.[8] Eventually, he conceived the idea of a subsidized gallery that would act as a platform for advanced work. With Dudley as founding director, the gallery opened in 1991 with a preestablished stable of twenty artists (figure 3). It was always clear that Joseph's intent was not to make money, but rather to cement furniture's status in the commercial art world—using a promotional arsenal that only a well-financed luxury gallery could afford. His Midtown salesroom was upscale, spacious, and deluxe; he spent considerable money on glossy color advertising; and like a museum, he published illustrated catalogues for which he commissioned such well-known writers as Witold Rybczynski and Arthur Danto.[9]

In contrast to many other gallery owners in the crafts world, Joseph was profoundly unsentimental. Many of the craft galleries of the 1980s had their origins in the grassroots scene of previous decades. And for most makers and sellers of furniture, money was a hurdle to be jumped, a barrier that prevented creativity from running its full course. Generally speaking, the "first generation" of studio furnituremakers had held that the great rewards

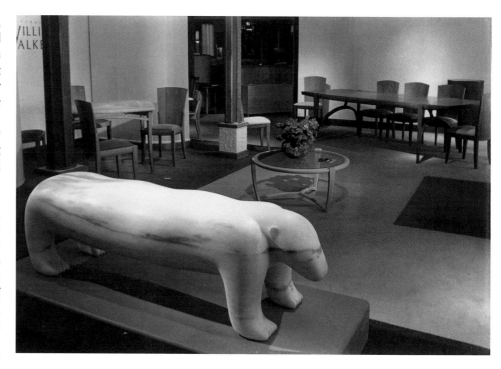

Figure 2. An exhibition of furniture by Judy McKie (foreground) and William Walker (background) at Pritam & Eames Gallery. Photo courtesy Pritam & Eames Gallery

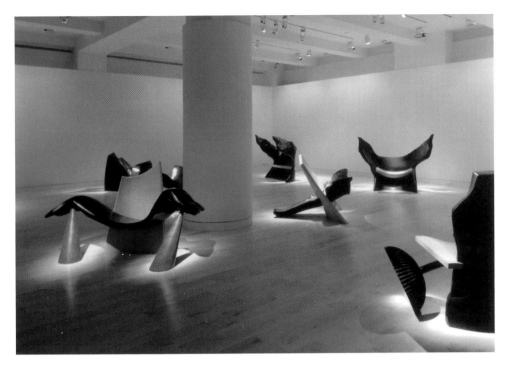

Figure 3. Wendell Castle's exhibition *Angel Chairs* at the Peter Joseph Gallery, 1993. Photo by Michael Galatis, courtesy Lorry Parks Dudley.

of working in wood were intangible: connecting to the "soul of a tree," in the words of George Nakashima.[10] Even for the less romantic artists of the 1980s, money was definitely the problem, not the answer.[11] This mindset was totally foreign to Joseph's way of thinking, which had its premise in the idea that cultural and monetary value should be equivalent. That is, he felt that a great piece of furniture *should* cost a great deal of money: that was the marker of its greatness. So Joseph concentrated not only on liberating his artists, but also on making them solvent. As Lorry Dudley puts it, "he was a buyer and seller of companies. It was like trying to make twenty small businesses function."[12] To this end, Joseph fell back upon his legal expertise and drafted detailed contracts with the artists in his stable. Sometimes, these were relatively brief, but they could also run on for fifty pages or more. All the particulars of the artist's financial relationships with the gallery were spelled out. Most of the artists were given a stipend retainer, which gave them the freedom to create large-scale pieces or complex, interrelated bodies of work. And for these products, Joseph charged—and got—unprecedented prices. This was not so much to increase his profits as to demonstrate through sheer dollar values that furniture had "arrived."

Predictably, this strictly professional approach to selling furniture raised hackles in a field that was marked by convivial informality. Some found Joseph's approach to business paternalistic; others charged him with increasing prices beyond the point that the market could reasonably bear. Those outside of the gallery's chosen twenty had the greatest reason to feel unhappy, as they were left out of the advantages imparted by the high-profile showroom, but reaped the same difficulties of increased expectations. Yet it is undeniable that Joseph's gallery was the stage on which the most ambitious work of the era was created. As with any powerful dealer of contemporary art, his choice of artists was both presciently perceptive and a self-fulfilling prophecy. Today's leading makers are still, by and large, the people that Joseph included in his gallery stable. His list may have been "an artificial élite," as Rosanne Somerson notes, but the makers on it quickly took on the responsibilities of leadership.[13] This provided a marketplace confirmation of a trend that Cooke had described in his essay for *New American Furniture*: the dominance in the field of degree-granting university furniture programs. Almost all of Joseph's artists were faculty at these programs or had attended one or another of them. If it is true, as Donald Fortescue

has observed, that "the distance between the self-trained and the academically trained seems to have increased in the last ten years," then it was the Peter Joseph Gallery that was the most effective machinery of distinction.[14]

As suddenly and dramatically as the Peter Joseph Gallery appeared on the scene, it departed. Tragically, Joseph fell ill, and his gallery closed shortly before his death in 1998. Other venues have filled the gap left by his departure—the mammoth Sculptural Objects and Functional Art (SOFA) exhibitions in Chicago and New York, as well as smaller "niche shows" like the Philadelphia Furniture Show.[15] Of course, the continuing vitality of galleries has played the greatest role, and established gallery professionals have been joined by a new generation who follow in Joseph's footsteps, in that they are oriented to the "fine art world" in terms of marketing and subject matter (these include Leo Kaplan, John Elder, Franklin Parrasch, and Lewis Wexler). Moreover, despite Joseph's qualms about the constraints of the commission process, much of the advanced furniture of the last few years has been made at the behest of permissive clients who themselves have aspirations to greatness. This, perhaps, is Joseph's most important legacy: the idea that furnituremakers should and can support themselves even while taking artistic risks. It is no overstatement to say that the future of the field depends on the success of this formula, even if it is a difficult balance for most makers to achieve.

Figure 4. Michael Fortune demonstrates wood bending at the 1997 Furniture Society conference Furniture '97: A Celebration of the Art of Furniture Making, Purchase College, New York. Photo by Rick Mastelli

This is not to say that the convivial aspects of the studio furniture have withered over the last decade, however. Far from it: in the late 1990s, two institutions were founded that have dramatically increased the interconnectedness of the field. The first of these is the series of meetings held at Emma Lake, a rural retreat in Saskatchewan organized annually by the furnituremaker and woodturner Michael Hosaluk and his circle of colleagues. "Emma," as its adherents call it, is focused on collaborative work among artists. Although a handful of critics and collectors have been invited over the years, for the most part everyone involved is a craftsperson. And while most of the participants are either turners or furnituremakers, metalsmiths, painters, and the like have also taken part. The resulting work exhibits both the exuberance and the incoherence of wild experimentation. But the physical products of the meetings are not really the point. Instead, Emma Lake has joined the long tradition of craft as a pastoral retreat from the concerns of the marketplace and the isolated studio.

The Emma Lake phenomenon exemplifies the communal ideals of the craft movement, but its impact is limited: the site is remote, and only fifty people can attend each year. For everyone else, there is the Furniture Society (figure 4). Founded in 1996 under the leadership of Virginia furnituremaker and educator Sarah McCollum, the society is a broad-based organization that holds annual conferences, varying locales so as to reach new audiences of craftspeople each year.[16] Two previous attempts to create

an organization devoted to the medium had failed, and many involved with the society recall some initial skepticism as to the organization's chances.[17] Fortunately, such doubts have proved to be unfounded—thanks to thoughtful planning on McCollum's part, the camaraderie and effectiveness of a large group of dedicated founding trustees, and a tremendous need for community on the part of makers themselves. The Furniture Society presently boasts hundreds of active members, publishes ambitious volumes of criticism, history, and publicity, and performs myriad other promotional tasks. Its mandate, "to advance to art of furniture making," is explicitly proselytizing and embracing, theoretically taking in all forms of the craft, in any material. In this respect, the Furniture Society differs from its analogues in other media, such as the National Council for Education in the Ceramic Arts, Glass Art Society, and the Society of North American Goldsmiths, which are all devoted to specific materials and craft techniques. Definition based upon a genre of object, rather than a particular craft (e.g., woodworking), has been a particular advantage of the Furniture Society. Its territory is bounded by social rather than technical characteristics.

Yet the most vexed problems that the Furniture Society has had to confront over its five-year existence are those of self-definition. It has brought the field of studio furniture to another crossroads, similar to the one it faced a decade ago, and it is beginning to grow out of that period of imagination and exploration that marks young organizations. As Andrew Glasgow, the newly minted executive director of the society, puts it, the group is only now fully able to "realize the magnitude of its programming," and not a few people are amazed at what has been accomplished.[18] But with maturity comes the increasing burden of nailing down its personality and outlook. This is a difficult task, because alternate allegiances seem to impinge from every side. These destabilizing influences can be categorized into three areas: design for industry, period reproductions, and sculpture. None of these is entirely new to studio furniture. The postwar studio-craft boom was partly based on the premise that making objects by hand might provide valuable insights for industrial manufacture; period reproductions have been constructed continuously by hobbyists since the early days of the colonial revival in the late nineteenth century; and the idea of "craft as art," that is, as a subspecies of sculpture, has been a point of constant debate since the 1960s.

Nonetheless, the history of studio furniture's last ten years has been unusual in the intensity of its contemplation of these three alter-egos. The first of these—the field of "contract design" for mass production—may hold the most appeal and incentive for young makers, but it is also the most distant (figure 5). This is so despite a long tradition of "designer-craftsmen" organizations, which were formed in the 1940s and 1950s for the purpose of guiding people towards participation in the marketplace, normally by promoting considerations of function, elegant form, and suitability for mass replication. These ideas ebbed during the 1960s and 1970s, when studio craft in general went through a romance with the sculptural avant-garde and, subsequently, an equally romantic involvement with "lifestyle." In the 1990s, however, the idea of the studio as a factory-friendly proving ground for industrial manufacture came back into vogue. The American Craft Museum's 1991

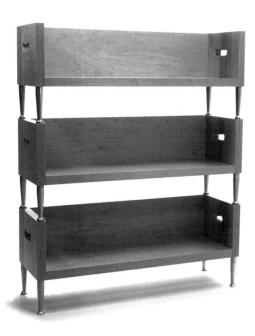

Figure 5. *Tier Shelves* by San Francisco furniture designer Christopher Deam. Photo courtesy of the artist

exhibition *Explorations II: The "New" Furniture* effectively embodied this ambition by pairing handmade pieces with the work of designer Dakota Jackson, whose work seemed to ape the expressive qualities of recent studio furniture.[19]

And indeed, over the past decade studio makers have overtly sought connections with the more lucrative and prestigious world of design, with some success. The exaggerated cartoon style of studio makers like Richard Ford has gradually penetrated the mass market, and a handful of craftspeople, such as Canadian Michael Fortune, have been able to sustain side-by-side commitments in production and one-of-a-kind work.[20] These isolated success stories have motivated overtures by the Furniture Society towards the design community through its conference programming. Small-scale, or "salon," designers were aggressively recruited as attendees for the 1999 conference in San Francisco, where San Francisco Museum of Modern Art design curator Aaron Betsky and California College of Arts and Crafts (CCAC) professor of design Christopher Deem were among the speakers. The following year in Toronto, a variety of designers such as the Canadian Paul Epp and Rod Wales from England contributed to the proceedings. In addition, some studio furnituremakers have tried to carve out a niche in design exhibitions such as Design Exchange in Toronto and the International Contemporary Furniture Fair in New York, but with only limited results.[21] The tight strictures of the regimented contract design world will likely prove insurmountable for the foreseeable future. The inertia of the heavily capitalized, risk-averse mass production furniture industry is overwhelming, to say the least, and it is probable that the late 1990s will eventually be regarded as a high point in the mutual engagement of the two fields. Nonetheless, the formal sophistication and precision of contract design furniture has made a deep impression on some studio makers, and many students graduate from studio programs and head directly into jobs working for industry. In this regard, the "designer-craftsman" ideal of handwork as a laboratory for the factory may yet come to widespread fruition.

If the design field has played hard to get with the Furniture Society, then period reproduction makers have likewise had a difficult time gaining acceptance among their more avant-garde studio colleagues (figure 6). Partially, this is because reproduction craftspeople have their own separate infrastructure. The North Bennett Street School in Boston, a facility with roots in the Arts and Crafts movement, has long been a national center for the practice and teaching of historically inspired furniture. And in 1999, a new organization called the Society of American Period Furniture Makers (SAPFM) was formed. Now 300 members strong, it shares information and enthusiasm at its annual conferences in Williamsburg, Virginia, in much the same way that the Furniture Society has done for its members.[22] To an outsider, the differences between the two groups may seem slight, but the Furniture Society's leadership is mainly academic, and thus far the course they have set is, as Andrew Glasgow concedes, "more cognitive than practical."[23] SAPFM's current director Steve Lash concurs that "the two organizations really have separate directions ... We have our own agenda, and it's not an agenda that will lend itself to being a subsidiary."[24] At the Furniture

Figure 6. Stephen Latta, Doug Mooberry, and Kevin Arnold (left to right) with a reproduction breakfront made and inlaid by Latta and carved by Arnold. The piece was produced for Kinloch Woodworking, which Mooberry owns. Photo by Boyd Hagen, courtesy of Taunton Press

Society's 1998 conference in Tennessee, however, there was considerable debate about the place of period reproduction makers in the organization. The questions were real ones: should the society serve the interest of people who work primarily for the technical challenge (as opposed to a stylistic or intellectual one)? Do the pragmatic interests of the reproduction makers constitute a well of knowledge that more innovative makers should learn from, or is the pursuit of raw skill at the bench a distraction from the conceptual preoccupations that contemporary furniture should adopt? In these discussions, it is often overlooked that reproduction work itself is quite varied, encompassing not only the venerated styles of the colonial era but also Arts and Crafts, Art Nouveau, and Art Deco. Carefully calibrated variations on these iconic styles certainly constitute a deep formal engagement with furniture. It may be that such innovations are often at the level of engineering rather than style or content; but still, this is an approach that the mainstream studio maker might take more seriously.[25]

The final identity with which studio furniture flirts today, that of sculpture, has always been entrancing and elusive for craftspeople, and it will no doubt continue to be so. Claims for handmade furniture's status as art extend back at least to Wendell Castle's stack laminated works of the late 1960s, but for the most part the fine art establishment has proved even more impenetrable than the industrial design complex. Some of the blame for this rests on the makers themselves. Many have been quick to claim fine art status, but very few have tried to engage with contemporary art's rich and complicated theoretical discourse. If studio furniture wants to compete on an equal footing with painting, video, and installation art, it will not be easy. Yet there is some hope that the field's already viable avant-garde segment will continue to blossom. It is only in the past decade that a large number of young makers have

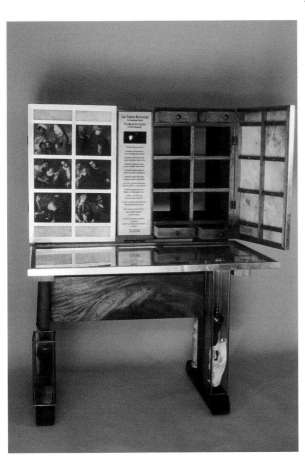

Figure 7. Lalo Cervantes, *The Caste Vargueño, a Partial Assembly: A Secretariat for Precarious Writing*, 2000. This cabinet by a recent graduate of the California College of Arts and Crafts exemplifies the use of complex subject matter by emerging furnituremakers. In it, Cervantes incorporates sources as diverse as eighteenth-century Mexican painting, traditional Hispanic colonial furniture, and his own DNA. Photo courtesy of the artist

been able to learn a great deal about contemporary art while developing their skills in the woodshop (figure 7). This has been the direct result of entrenched academic programs at schools with a broad art curriculum, where furniture students often take courses with a broad panoply of professors in sculpture, painting, and photography as well as other crafts.[26] Wendy Maruyama, the head of the San Diego State University furniture department, has been surprised by the results: "The newer generation (late nineties and current grad students) are still idealists and are willing to push the envelope experimentally. [M]ore and more are incorporating computer technology to create images to be incorporated into the works or to start using interactive video inside furniture or over it ... In my program there is no line between sculpture and furniture, these have been able to coexist seamlessly."[27] Likewise, professors of woodworking in many universities frequently find themselves advising and teaching students from the tradi-

tional fine arts departments.[28] Recently, many young sculptors have continued to pursue fine craftsmanship for its rhetorical and formal power (among those who use furniture as part of a cutting-edge artistic vocabulary, Robert Gober, Mona Hatoum, Doris Salcedo, Sarah Sze, and Rachel Whiteread stand out). Hopefully, such cross-pollination will continue; this can only be to the benefit of the furniture field, which can learn much from the conceptual rigor and the headlong desire for innovation that marks the contemporary art world today.

Perhaps the most satisfactory result that studio furnituremakers might achieve by looking at these disparate and contrasting fields is a firmer sense of their own objectives. If the Furniture Society has accomplished anything, it has been the permission to think outside the boxes of rigid definition. This openness comes from frequent and candid discussion and an increasing awareness of the history of studio furniture itself, with all its possibilities and roads not yet taken. In the end, studio furniture is not industrial design, nor is it period reproduction, nor is it (only) sculpture. But it does partake of the strengths of each of these categories: the exacting demands of drafting a chair on a computer; the technical and aesthetic pleasures of recreating an eighteenth century chest; and the intellectual heft of postconceptual art. But it is more than the sum of these parts as well. It is, above all, a community, and one that has an increasing sense of its own importance.

Glenn Adamson is the curator of the Chipstone Foundation, where he helps to prepare exhibitions for the Milwaukee Art Museum, and teaches at the University of Wisconsin–Madison.

Notes

1. I would like to acknowledge the following people for assistance in the preparation of this essay: Judy Coady, Lorry Dudley, Dennis Fitzgerald, Donald Fortescue, Andrew Glasgow, Stephen Hogbin, Bebe Johnson, Steve Lash, Steven Latta, Tom Loeser, Wendy Maruyama, Craig Nutt, Toni Sikes, Mark Sfirri, and Rosanne Somerson. And last, I wish to acknowledge my debt to the teaching and writing of Edward S. Cooke, Jr. I doubt that anyone could write an essay like this one without reckoning with Cooke's previous work, but his contributions loom particularly large on my own mental landscape. I have benefited from his teaching at Yale University, where I was a graduate student up until last year, and it was thanks to him that I became involved with the studio furniture field.

2. Nancy Corwin, "Vital Connections: The Furniture of Daniel Jackson," *American Craft* 50, no. 3 (June-July 1990): 74, footnote. See also Mary Frakes, "American Studio Furniture: The Second Generation," *American Craft* 50, no. 2 (April-May 1990): 33–38.

3. Jonathan Fairbanks, "Foreword," in *New American Furniture: The Second Generation of Studio Furniture-makers*, ed. Edward S. Cooke, Jr. (Boston: Museum of Fine Arts, 1989), 7. Fairbanks had paved the way for the exhibition in his well-known and widely imitated "Please Be Seated" program, in which contemporary makers were invited to create functional gallery seating for the museum. See Fairbanks et al., *Collecting American Decorative Arts and Sculpture* (Boston: Museum of Fine Arts, 1991).

4. Cooke noted in the essay that he had adapted the concept of a discrete "first generation" from discussions in the 1960s and 1970s. See Cooke, catalogue in *New American Furniture*, 29, note 4. Cooke notes that he "simply extended the term and provided some sense of what it stood for." Cooke, communication with author, 28 August 2001.

5. Edward S. Cooke, catalogue essay in *New American Furniture*, 10.

6. Cooke also provided an incisive analysis of this boom market, in "Wood in the 1980s: Expansion or Commodification?" in *Contemporary Crafts and the Saxe Collection*, ed. Davira Taragin (New York: Hudson Hills Press/Toledo Museum of Art, 1993).

7. The age of the craft fairs was inaugurated with the ACC's first in Rhinebeck, NY, in 1972; the fairs grew in size and prominence throughout the 1970s and, by decade's end, had become the major market event in the crafts. On the heels of this success other fairs were launched during the 1980s, such as the Crafts at the Armory in New York and the Philadephia Museum of Art Craft Show.

8. Dudley had been the head of the gallery Grace Designs in Dallas as well as a touring exhibitions company called Exhibitions, Inc. She is currently the U.S. director of retail marketing for Vitra and the Vitra Design Museum.

9. Despite the promotional nature of these brochures, they were really the only sustained format for discourse in the field at the time. Given its broad mandate, *American Craft* gives only occasional attention to furniture. The publications devoted exclusively to the field, such as *Fine Woodworking* and *Woodwork*, both emphasized technical rather than critical writing at this time in their histories.

10. George Nakashima, *The Soul of A Tree: A Woodworker's Reflections* (New York: Kodansha International, 1981).

11. For a wonderful account of the trials and tribulations of attaining success as a "second-generation" maker, see Alphonse Mattia's interview in *The Craftsperson Speaks: Artists in Varied Media Discuss Their Crafts*, ed. Joan Jeffri (New York: Research Center for Arts and Culture of Columbia University/Greenwood Publishing, 1992).

12. Lorry Dudley, interview with the author, 30 August 2001.

13. Somerson, communication with author, 1 July 2001. Somerson is a furnituremaker and professor at Rhode Island School of Design, and a member of Joseph's stable. It is worth noting that Joseph bears a close resemblance to a previous New York dealer named Lee Nordness. Like Joseph, Nordness was a latecomer to the world of studio craft, having previously been a painting and sculpture dealer. And, like Joseph, he had great ambitions for his newfound field. Nordness's signal accomplishment was the exhibition *Objects: USA*, a survey of studio craft in all media that toured twenty American and ten European venues between 1969 and 1972. During the process of organizing the show, Nordness took on the artists he viewed as the most successful and experimental in his own gallery. He showed a particular attachment to the work of furnituremaker Wendell Castle, who was later among the leading lights in Joseph's gallery.

14. Donald Fortescue, communication with author, 7 August 2001. Fortescue is a sculptor and heads the wood department at the California College of Arts and Crafts.

15. The phrase "niche shows" and my sense of their importance are both drawn from Craig Nutt, communication with author, 3 August 2001. The Philadelphia Furniture Show was cofounded by Joshua Markel and Bob Ingram in 1995.

16. This year's conference will be held in Madison, Wisconsin, in conjunction with the present exhibition. Previous sites have been Purchase, New York (1996), San Francisco (1997), Smithville, Tennessee (1998), Toronto (1999), and Tempe, Arizona (2000). The first conference was accompanied by an exhibition at the Neuberger Museum of Art; see "Furniture Forward," *American Craft* 57, no.6 (December 1997-January 1998).

17. The two precursor organizations were the Society of American Wood Workers (SAWW) and the American Society of Furniture Artists (ASOFA). Both were founded in the 1980s and lasted only a short while.

18. Andrew Glasgow, communication with author, 3 September 2001.

19. See Joshua Markel, "Exploring the 'New Furniture,'" *American Craft* 51, no. 4 (August-September 1991): 56–62. Markel observed that "[Jackson's] success in adapting an artist's sensibility to the requirements of mass production points to a possible future role for the diverse furnituremakers represented in 'Explorations II.'"

20. I thank Dennis Fitzgerald for his observations on this phenomenon, including these two examples. Communication with author, 4 September 2001.

21. Craig Nutt, communication with author, 3 August 2001; and Stephen Hogbin, communication with author, 12 and 13 July 2001.

22. For more on SAPFM, see its journal *American Period Furniture*; Cornelia B. Wright, "Society Offers Forum for Period Furniture Makers," *Early American Life* (August 2001): 26–31; and Jason Marshall, "SAPFM Report," *Woodwork Magazine* 67 (February 2001): 32.

23. Glasgow, communication with author, 3 September 2001.

24. Steve Lash, communication with author, 2 September 2001.

25. For a more extended discussion, see my profile of the Federal furniture reproductions of Massachusetts maker Harold Ionson: "Recreations: The Period Furniture of Harold Ionson," *Woodwork Magazine* 67 (February 2001): 24–31; and Rick Mastelli, "In Search of Period Furniture Makers," *Fine Woodworking* 23 (July 1980): 32–40.

26. In this group one thinks of the Rhode Island School of Design, the California College of Arts and Crafts, San Diego State University, Virginia Commonwealth University, Sheridan College in Toronto, and the University of Wisconsin–Madison. All of these institutions stand in contrast to the programs of the 1960s and 1970s, which focused intensively on the development of craft and design skills.

27. Wendy Maruyama, communication with author, 20 July 2001.

28. Tom Loeser, communication with author, 14 July 2001. Loeser heads the wood program at the University of Wisconsin–Madison.

Doors, Drawers, and Cases

Virginia T. Boyd

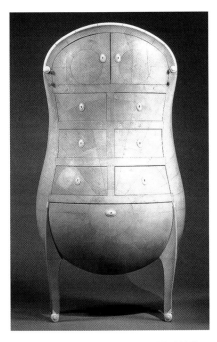

Figure 1. André Groult (French, 1884–1967), Chiffonnier, 1925. Musée des Arts Décoratifs, Paris

A cabinet or case is a container enclosing space. These containers order our lives by giving structure to our space, holding our possessions, and expressing our tastes. Serving us in many ways, they are infinitely variable: old chests of drawers scavenged from the flea market, sandalwood jewelry boxes inlaid with ivory, cold gray metal security boxes, smooth mahogany double chests enriched with rococo carving and lustrous brass hardware, black matte polypropylene cases for video players, the worn cardboard box of a street person, the case in which we rest at the end of life. In this exhibition we selected a group of contemporary cases with which to explore this chameleon object's many faces and natures.[1] All of the artists represented in *Contemporary Studio Case Furniture: The Inside Story* began with the notion of an object that addresses the function of containing and holding, either actually or conceptually.[2]

Cases are unique among furniture types. Other furniture is overt, revealing directly what it is. The user can see what it has to offer: something to put things on, sit or recline upon. In contrast, a case is covert, mysterious, revealing itself only in stages. The outside secretes what is inside, and how one passes from outside to inside is not always apparent or predictable. The moment of pulling a drawer, opening a door is a moment of suspended curiosity about the unknown beyond. Upon entering one may be confronted with more levels of containment, of boxes within boxes. Thus, there is always a sense of expectation when approaching a case piece. The combination of case and contents often gives value and meaning beyond either individually. The power of the medieval relic is amplified by its lavishly bejeweled and encrusted silver case; alone, the piece of old bone has little aura.

Humans have a curious symbiosis with case furniture. The human body is in a sense an animate case; thus we have an instinctive resonance with the inanimate form, even using anatomical terms to refer to parts of cases: leg, chest, back, waist. Not only do we share jointly our everyday spaces, but we have intimate physical interactions with cases as they serve our needs and desires. André Groult (figure 1) expressed our common nature as cases, a chest of drawers with the form of a bosomed, hourglass-shaped woman. The creamy tone and smooth texture of the veneer enhance the connection. The close relationship between people and furniture is also due the power of our sense of touch. As Juhani Pallasmaa emphasizes, touch is our most potent and elemental sense. [3] We trust information acquired from moving our hand over a surface or from sitting on a chair more than information acquired from sight alone. Furniture has a tactile, participatory relationship with the user.

A major impetus for this exhibition was to present the work of current makers and through them to recognize the long and creative furniture tradition that continues uninterrupted into the present.[4] Comparison of the exuberant cases of seventeenth- and eighteenth-century French and American cabinetmakers (figures 2, 3) with those of contemporary furniture artists John Cederquist (see plate 4) and Jenna Goldberg (see plate 10) demonstrates that the creative, robust cabinetmaking tradition of the past is irrepressible.

It Is All about Space

Cabinets are first and foremost an articulation of space. As Gaston Bachelard indicates in *Poetics of Space*, a case is simultaneously a shell enclosing a volume of space and a mass nested within larger cases—a room and building.[5] Cabinets define how a certain space is to be used and understood. The surface of a case is a boundary that simultaneously delimits an interior space and establishes a position in the vastness outside.

All art forms involve space and form but in different configurations. A painting is generally a thin plane of minimum mass. Yet visually a painting can represent great expanses of space through imagery in perspective on the surface. And generally the viewer/user is physically distanced in space from it. In contrast, the interior spatial volume of a ceramic object is of major significance to the whole, and the user makes tactile contact with it.

An enclosed case confronts us with the existence of an unknown yet potentially accessible world. What secrets does it hide? Christopher Vance's *Staircase* (see plate 33) is about our desire to know what is inside the little box at the top that emits a softly glowing light through a frosted apricot door panel. He beckons us upward on steps of diminishing depth and increasing height, which create the illusion of even greater height. The contradiction of drawing us upward, yet keeping us outside creates an unresolved tension. The spatial complexity of the piece is revealed further on close detection. The case is, in actuality, not only a staircase to a mystery but a very large functional chest of drawers. The front edge of each stair tread is a hand pull for a drawer, each drawer graduated in size from those above and below it. In this piece Vance has extended the traditional Japanese dual-function stair cabinet through repositioning the drawers and commenting about ascent and concealment.

Wendy Wiesner challenges the assumption that contained space is necessarily concealed space. She asks us to think about the space of a cabinet and a room as a single continuous volume within which the case floats, much like a plastic bottle submerged in a pool of water. Her diaphanous piece *Caged* (see plate 35) is composed of a delicate curvilinear armature of steel rods covered with fine-gauge wire cloth. One can see into the case, past the shelves, and through the case to the space beyond. Is it a case when the outside and inside space are continuous, without concealment? And yet the form is about containment, separating interior from exterior, requiring the door to be opened to engage the function of the case. *Caged* is thus ambiguous; the privacy expected is replaced with exposure. In great contrast, in

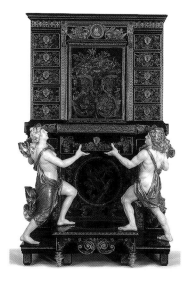

Figure 2. Attributed to André-Charles Boulle (French, 1642–1732), cabinetmaker, and Jean Varin (1607–1672), medalist, Cabinet on Stand, about 1678–1680, oak veneered with ebony, pewter, tortoiseshell, pewter, brass, ivory, horn, and various woods; with drawers of snake wood; painted and gilded wood figures; bronze mounts, H: 7 ft. 6 ½ in.; W: 4 ft. 11 ½ in.; D: 2 ft. 2 ¼ in. J. Paul Getty Museum, 77.DA.1

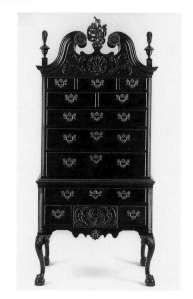

Figure 3. American, High Chest, ca. 1755, H. 94 x 23 ¾ in. Chipstone Foundation, 1992.9

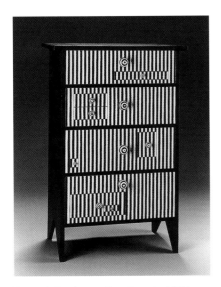

Figure 4. Tom Loeser (American, b. 1956), *More Multiple Complications* (chest of drawers), 1999, zebrawood, mahogany, milk paint, 55 x 34 x 21 in. Milwaukee Art Museum, Doerfler Fund purchase, M1999.52

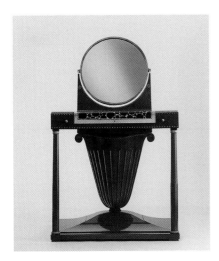

Figure 5. Emile-Jacques Ruhlmann (French, 1869–1933), Dressing Table, ca. 1919–1923, oak frame with Andaman padouk (base and vase) veneer, purpleheart (amaranth) (top and mirror back, solid columns), inlaid with ivory and ebony; mahogany drawers; silvered bronze mirror frame and fittings, 44 x 30 x 20 ½ in. branded into underside of top: 'Ruhlmann' (script signature), Victoria and Albert Museum, London, W.14-1980/ Art Resource, NY

Jim Rose's cabinet (see plate 25) the interior space is enclosed, secluded, and dark. The case is a visual and physical boundary between two spaces, outside and inside.

A cabinet is essentially the skin surrounding a volume, the physical boundary that separates space outside from that within. It is also the metaphysical gatekeeper between the spaces of our private inner world and the public outer world shared by others. Yet without points of entry through the skin a case would be an inert mass and the boundary would mediate nothing. Doors, drawers, and lids provide the means by which we interact with a case through storing and retrieving and passing between our inner and outer psyches. When doors are closed, the presence of the case is directed to the larger world; when open the outside world is totally forgotten; the case invites the opener into the intimate interior. A half-open door breaks the rigid separation of interior versus exterior and creates a sense of transition. We cannot fully understand a case without physically opening it, looking, and reaching into it.

Artists explore the drawer and door as transition among spaces. Thomas Loeser (figure 4) creates complex puzzlelike internal compartments through constructing drawers within drawers. His cases often have a hierarchy of interior spaces that the user must discover and follow in sequence in order to use the drawers. Loeser prompts one to rethink the role of drawers; are they simply the entry from outside to inside, functional receptacles, or mechanisms for engineering complex spatial structures?

Wendy Maruyama (see plate 18) proposes that the boundary of the case can also connect our public and private worlds. Our outer façade can simultaneously expose a glimpse of our inner self. A bold, arresting shieldlike shape composed of two large doors of lustrous gold leaf dominates the exterior of *Peking*. The shield is two oversized pulls for two large doors. On a plane slightly behind this powerful image is a vertical strip of subtly graduated, deeply saturated colors, which are the fronts of a set of almost inconspicuous drawers. The abrupt shift in attention from the aggressive, extroverted shield to the quiet, slightly set-back drawers has, in fact, made the transition to the interior space and world without even opening the doors. When the large protective doors are opened, the drawers are revealed to be the heart of an immense interior space. The lush, dark colors of the interior suggest the serenity and expansiveness of a deep night sky or the interior of a black lacquered box. From the title of the piece we feel an Asian edge, yet absent any specific details it remains allusive. Thus Maruyama gives opportunity for another meaning to adhere. Although her cases recall the elegant, curvaceous cases with lavish surfaces of Emile-Jacques Ruhlmann (figure 5), Maruyama's cases, unlike Ruhlmann's, reflect the new expressiveness of contemporary furniture. They have something to say in addition to a beautiful body.

Charles Radtke's *Leaf Cabinet* (see plate 24) appears to enclose space in the conventional way, accessed through doors. However, in actuality the structure is a construction resembling separate planes with only minimal points of intersection. The space of the case is thus quite open; air flows languidly through openings between planes. The black fields behind the

jewelrylike enameled leaves (by artist Sarah Perkins) are not solid but rather are the velvety darkness of the interior. The case has the spatial airy lightness of a structure made of playing cards. The calm elegance of Radtke's cabinet is in stark contrast to the high emotional pitch of Brian Wilson's cabinet (see plate 36), although both have a somewhat similar open spatial structure. In *Keeper of Memories* the interior space leaps out at us. The broken boundaries and wired, fragmented parts suggest that the case could not contain the pressure of the memories within. The deconstructed case became a dysfunctional sieve through which memories fly out like a cloud of silent bats at dusk, watched over by a shadowy, dark-angel.

Through unexpected spatial juxtapositions in *Ark* (see plate 23) Gordon Peteran dislodges and disorders our preconceptions about our spatial relationships with cases. We expect a cabinet to be positioned within increasingly larger cases, occupying space within a room, and the room a case within the case of the building. We understand ourselves as living outside case pieces and within the cases of room and building. Peteran upends these expectations. He places us, not outside the case but within the space of a case, thus forcing us to redefine the categories of spaces. Are we now in a tiny room, which the cushioned seat and overhead electric light would indicate, within a larger room? Or have we become one of the things we put into a case piece and thus have become merely an accouterment? The gable of the case suggests that it is, in fact, a house unexpectedly miniaturized and placed within a room. He disorients us further with the oversized eye screws at the corners of the roof of the case/house that conjure up suspending the cabinet (and us) in air like a bird in a cage.

Furnituremakers have long employed the magic of illusion to create space, deceiving the eye with images on surfaces that are not what they seem. Using the classic French bonheur-du-jour desk, (figure 6) Silas Kopf concocts his own deception (see plate 15). French cabinetmakers used exquisitely crafted objects such as this to display their formidable mastery of marquetry with areas of complex trompe l'oeil imagery. Kopf uses the same desk form, marquetry technique, and illusionistic imagery to create a work contemporary in content. On the flat surface of the desk cover he crafts an illusionary still life of a hypothetical twentieth-century writer's desk with typewriter prepared with paper, box of sharpened pencils, and books for reference. The spatial illusion is so compelling that one has little desire to open the case up to see the actual space inside, suspecting that the spatial illusion on the cover may be more interesting than any space within.

John Cederquist captures the viewer through even more complex illusions in *Tubular* (see plate 4). The lineage of the piece reaches back to large cabinets on frames (see figure 2) and the surface illusions of Piero Fornasetti on Gio Ponti's cabinet (figure 7), for example. But both Fornasetti and Kopf clearly ground the viewer; we easily perceive the structure of the piece. However, Cederquist not only creates complex illusions on the surface of the case, but the illusion is extended to the case itself. The object does not state its actual structure directly. In reality the case consists of a large flat plane on the front facade on which the illusion is painted, a huge rainbow-hued wave (a nod to Katsushika Hokusai's *The Great Wave off*

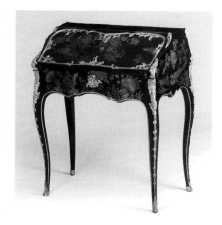

Figure 6. Attributed to Jacques Dubois (French, ca. 1693–1763), Writing Desk (rococo bonheur-du-jour), 1745–1749, black, red, and gold European lacquer, oak, pine, mahogany, kingwood, leather, pewter, iron, chased and gilded bronze, 35 1/2 x 30 3/4 x 18 in. Art Institute of Chicago, 1973.385

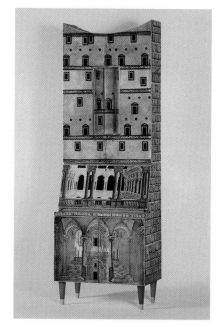

Figure 7. Gio Ponti (Italian 1891–1971), decorated by Piero Fornasetti (1913–1988), Writing Cabinet, 1951, screen-printed Masonite on laminated and solid wood, varnished, 87 3/4 x 31 3/8 x 15 3/4 in. Victoria and Albert Museum, London W.21-1983 / Art Resource, NY

Kanagawa blockprint) crashing through a stack of packing crates. Behind this flat front surface is a case, smaller in dimensions than the facade. *Tubular* resembles the elaborate false storefronts of hastily assembled frontier towns. Without direct contact with the piece it is virtually impossible to understand the actual form or discover the drawers, hidden within the illusion of the facade. The incongruous is Cederquist's territory, disengaging what we think we know from what we think we see.

Is It Sculpture?

In *The New Furniture* Peter Dormer suggests that within the current blurring of categories of craft and art, case furniture and sculpture are being rethought from both sides.[6] Both explore space through form yet in different ways. Fabiane Garcia's *Still Life 4* (figure 8) succinctly illustrates simultaneously the two different approaches to space and form. We can think of space as volume (the chest has functional interior space) or as mass within a larger space (we perceive the apple and pear as solid objects; we have no interest in their interiors). When we value space as volume, the interior void is significant to the purpose of the form. Thus furniture cases traditionally embrace this definition of space. In contrast, in space configured as mass the interior is largely unimportant to the object, whether hollow or solid. Traditional sculpture approaches space this way, largely ignoring any void within and projecting an expressive presence and meaning outward to the viewer.

Figure 8. Fabiane Garcia (American, b. Puerto Rico 1960), *Still Life 4*, 1994, polychromed, carved, constructed wood, 36 x 43 x 20 in. Courtesy of the artist

Studio furniture artists exploit the opportunities unique to cabinets in that they can upset our expectations about space and form in cases and sculptures. In *Overturned Ore Car* (see plate 13) Skip Johnson appears to take a sculptural approach, creating a workaday vehicle for the refined environment of art. Everything he wants to say seems to be on the surface, we care little about what is inside. However, Johnson surprises us with an unexpected disjuncture between what we think we see and what is present. The car is actually a case with a functional interior volume, a side panel is a door, which opens to reveal an interior space fitted with for a bar.

In *Broom Cabinet* (see plate 3) Andy Buck gives prominence to one of the myriad of essential yet virtually invisible objects that float through our daily lives. The humble broom is transfigured into a totem by encasing it in a box shaped to its ever-familiar silhouette and with attention-grabbing, bold black-and-white stripes on the surface. The encasing bestows a mantle of self-awareness to the broom. As Clark Kent divested himself of shirt and tie to reveal Superman, the broom bursts into the foreground of life in a snazzy new suit. Buck's case does for the humble broom what the extravagant sarcophagus of an Egyptian pharaoh did for the fragments of skin and bone inside: the common becomes uncommonly important.

Garry Bennett's *Black Buffet* (see plate 2) gives a twist to a central theme in twentieth-century sculpture, exploration of the expressive capacity of abstraction through formal elements of form and color. Although a statement on abstraction and nonobjectivity, the piece is a utilitarian case, in design and name. Bennett might be saying, Why settle for less when you can have it all, sculpture and furniture? Bennett's boastful buffet has a jaunty attitude similar to Ettore Sottsass's Room Divider/ Bookcase (figure 9), which also dances slyly and intentionally on the boundary of furniture/ sculpture. Both reach to popular culture for formal elements including simplified cartoonlike shapes and, in Sottsass's bookcase, populist materials such as plastic laminate.

Our instinctive tendency to anthropomorphize cases, thinking of our own body as a case, has often served as inspiration and metaphor. Extending back to the Greek concept of mimesis, made explicit by using a human figure for an architectural column, the caryatid figure continued to be used in furniture for centuries as in the encrusted cabinets of the French baroque (see figure 2). The body-as-column was replaced with the much closer parallel of body-as-cabinet by Salvatore Dali who morphed the ancient Roman statue of Venus de Milo into an ersatz chest of drawers, with ermine pulls on drawers positioned in forehead, breasts, and midriff. And André Groult explored the body-as-case with his pale veneered, anatomically feminized chest of drawers (see figure 1).

Bachelard extends the body-as-case metaphor. The being of a person is understood by others only from the person's surface; the core identity is concealed inside. In *White Guy* (see plate 32) Bob Trotman expresses this relationship between the outer and inner person. He depicts the torso of a middle-aged white male clothed in the suit of power of the twentieth century, details that identify *White Guy* at the pinnacle of control and social status. Yet the figure presents a discontented mood, head inclined and downward, arms clasped behind. The disconnected nature of this person/ case is reinforced by the few and small drawers, minimal points of entry into his privately held identity. Why is a man of resolve irresolute? *White Guy* reveals little.

In contrast, in *Persona #9: Teenager* Gayle Weitz (see plate 34) invites us to be voyeurs into #9's inner world. This body-as-case form presents the peculiarly American penchant to reveal all, to share our innermost being with the world. Unlike the few and tiny drawers of the *White Guy* that keep his self closed, one large full-length door exposes every corner of #9's inner and outer being, perhaps to the point of overexposure. These two cases illustrate the range and subtly of expression a cabinet can convey because of its physical feature of opening and closing, concealing and revealing. A case gives opportunities for meaning that objects with mass but no interior of consequence cannot. If we ask of both Trotman's and Weitz's case, "Where do I put my stuff?" we are not satisfied with either piece. But it is unlikely that we go away from either without thinking about the interaction between our public and private selves and those of others.

Figure 9. Ettore Jr. Sottsass (Italian, b. Austria 1917), Room Divider/Bookcase *Carlton*, 1981, chipboard wood, polychrome plastic laminate, 77 1/4 x 27 3/4 x 15 in. Milwaukee Art Museum, Centennial Gift of Gilbert and J. Dorothy Palay, M1988.118

In the past the link between the maker and user of furniture has been primarily through the appeal of craftsmanship and stylistic details. However, in *The Meanings of Modern Design*, Peter Dormer emphasizes that the most significant contribution of contemporary studio furnituremakers like Trotman and Weitz is to engage viewers intellectually, to view some cases not as a mute presence but capable of articulation of ideas with depth and subtlety.[7] The recent practice of giving cabinets titles to convey the artist's intent indicates this new voice for furniture forms. In *Making and Metaphor* Gloria Hickey and colleagues discuss furniture as narrator about the maker of the piece, ourselves, and the world in which we live.[8] Furniture artists draw on memory, fantasy, association, imagination, history, and many other sources to express themselves. As studio furniture artist Danny Birnbaum has said, "This is furniture with attitude."[9] Because storytelling invokes an intimacy between teller and listener, narrative is especially compatible with furniture with its inherent intimacy with people. However this new cerebral expressive content is in addition to, not replacement for, the functional nature of the piece, either conceptual or actual. And often the particular idea or story could not be fully stated without the functional nature of the case. The nostalgia of Tommy Simpson's *Firsts* (see plate 28) would not be communicated without the pie safe cabinet. Alphonse Mattia's conceptual play with "cybord," "sideboard," and "ironing board" would be impossible without the several functional furniture forms.

Of particular note is the use of humor and wit for communicating ideas through furniture forms. As the exhibition *Designed for Delight* [10] made abundantly clear, a sense of the absurd and playful in decorative art objects is not new and is alive and well today in many art forms. It permits a serious idea to be explored in a nonthreatening way, as a cartoon deals with sensitive issues through a light deft touch, as does Kim Kelzer in *Home on the Range* (see plate 14). She employs two stereotypic cultural icons to comment about social roles in American culture, the staunchly independent cowboy roaming freely over the open frontier and the housebound housewife whose circumscribed dependent life is tethered to the kitchen. Kelzer focuses on a feature of both stereotypes, the range—as landscape and household appliance. The domesticated kitchen range with burners, clock and knobs is present, but its normally smooth enameled exterior has become the tough, prickly, green hide of a cactus, an icon of the range outdoors. The domestic range seems to be swept along by an invisible wind; perhaps the inexorable winds of change blowing away prescribed roles and stereotypes. Kelzer may be asking, home on which range, wide open or circumscribed?

Contemporary popular culture is an ever-bubbling spring for commentary for furniture artists. Uncanny connections between the macho American male, past and present, are the stuff of *The Handyman Special* by Mitch Ryerson (see plate 26). The mythic two-pistol gunslinger of the past is conflated with the contemporary fix-it guy with the tools of his trade, two caulking guns loaded and extruding. The cowboy ranged the terrain of the frontier. The handyman ranges the gabled roof and clipped grassland of

suburbia. In a similar vein, Ed Zucca's *Cave Man TV* (see plate 37) plays on the popular "Flintstones" TV cartoon series simultaneously poking fun at our couch-potato instincts and infatuation with appliances for passive entertainment. The unexpected substitution of decidedly low-tech materials such as the screen of faux rock, tree branch frame, and pair of animal horns for antennae stops us short. He asks us to think about the objects that are the props for our habits. The piece is also a reverie about an earlier time when Ed Sullivan, Mickey Mouse, and "I Love Lucy" filled our screens and air. Worldwide TV beamed from satellites is still the future beyond Zucca's happy sunny time.

As Zucca uses a case as a mirror for us to see ourselves, other artists use the case to comment about themselves and issues with which they struggle as individuals. The title of Christine Enos's work, *Perfume, Potions, and Poisons* (see plate 8), conveys the curious alchemy of contemporary social expectations for women, simultaneously supportive and subverting. She combines a female torso and dressing table to make her statement, an apt choice as a piece of furniture particularly associated with a woman's personal world. Narrow shelves hold the instruments and elixirs used by women to create the facade presented to the world. The feminine, semitransparent fabric skirt, an integral detail on a traditional dressing table, suggests a veil, the most feminine of objects. A veil is a tool to reveal what one wants and conceal what one does not. For many artists the process of making a case is a search for a deeper understanding of themselves, and the cabinet articulates what they find.

Surfaces of Enrichment

At close range the surface of Cederquist's cabinet (see plate 4) simplifies to a bland flat painted plane. The intellectual complexity and visual thrill occur at a distance from the piece, where the illusion takes effect. However, for many case artists the primary zone of interest and complexity is the very close zone where the viewer's hand can touch the elaborated surface and the eye can see intricate detail. Continuing with the analogy of the human body as a case, these artists focus on the surface, the skin, the sliver of substance that presents the object to the world. The power of these pieces is experienced within the micro-space that wraps the piece. These surfaces do not seek a response from our intelligence. They are not concerned with self-expression or conceptual ideas. Rather they connect with a deeper realm, our experiential, sensate world. They are about the present moment and our deep pleasure in the sensual tactile effect when we touch their surface. The universal appeal of an elaborately carved relief surface that creates tactile richness is as old as furniture itself. Even roughly constructed early American Hadley chests (figure 10) display such surface embellishment. The fact that this extravagant carving was done in spite of a social context of meager resources, little time to invest in nonessentials, and minimal need for storage indicates the strength of our desire for visual and tactile enrichment.

Figure 10. Hadley-Hatfield Massachusetts Joined Chest, 1700–1710, oak with oak and pine, 45 x 36 x 19 $^3/_4$ in. Chipstone Foundation, 1988.21

Terms such as ornamentation, decoration, and embellishment are often used to describe elaborated surfaces, but the terms have come to imply a rigidity and conventionality that do not capture adequately the enlivened surfaces of several contemporary case artists. But the terms do convey the principle integral to the enriched surface: patterning is motivated by the desire to create visual order.[11] Our perceptual process seeks unity or wholeness when confronted with variation and complexity. The appeal of a pattern is thus the dynamic tension between the mind seeking predictability while elements of the pattern infuse variation within the order. Repetitions of elements, varying tempos of change, unexpected deviations, interconnections, and multiple levels of relationships keep our attention fixed on the surface as we ceaselessly explore the nature of the pattern's order and deviations within it.

Meyer Shapiro conceives the motivation for beauty as a passion for perfection of form and content.[12] Creation of a perfect order underlies Kristina Madsen's exquisitely carved cases (see plate 17). Her pieces present an intense experience of unity and completeness. Everything in the structure and ornamentation is precisely tuned to the whole. At least three irregular but ordered patterns are overlaid on the surface, created by chip carving through layers of veneers of different colors at multiple depths. Patterns in blue and red provide a field for a scattering of delicately curving individual dark lines. Relationships among the patterns change as the viewer's position in relation to the piece changes. The astonishing complexity yet muted subtlety of Madsen's panels are enhanced by the contrasting absolutely plain surfaces of the frame of the case that serve as a foil for the panels.

Jenna Goldberg also privileges senses over intellect in *Entry Cabinet* (see plate 10). Where Madsen's cabinet has a delicate refined quality, Goldberg's vertical cabinet has a stately, proud presence. It brings to mind simple, massive stone pylons. Yet what might be a brooding monolith is dissolved by the surface enriched with carved and painted pattern. The clean planes of the simple rectangular form are overlaid with a geometric grid. This is the foundation for a strong alternating syncopation, a bold visual pattern of sharp geometric shapes and lines and a subtle tactile pattern from the shallow-carved surface. The crisp black-and-white coloration increases the staccato rhythm. An entirely different effect is created in the interior. Opening the doors feels like looking into great grandmother's closet papered with a cozy white-on-red pattern of leaves and dots. The case back recalls narrow vertical wood tongue and grooved together for kitchen walls and cabinets. Goldberg opposes modernism and tradition through pattern.

Tom Loeser's surfaces are also micro-environments for creativity. In the *Roller* series (see plate 16) he chooses a large half circle motif to achieve multiple levels of interest visually and functionally on the surface of the case. By situating the straight side of each half circle along edges of the rectangular top, the motifs read as incomplete halves, not as stable whole circles. Thus he generates an energy at the edges as the eye tries to extend the frame of the top in order to complete the circles. Two additional levels of surface interest are created with low-relief carving. Each concentric band

within an arc is slightly concave, creating a fluted effect that intensifies the white painted in the recessed areas. And each full arc additionally is contoured to the shape of a sitter, much like the seat of a Windsor chair or tractor seat. This complexity of motif, color, relief, and contouring occupies physically only a tiny fraction of the total piece yet its visual power is great.

Nature's systems of visual and structural order have been important sources for pattern. The organic sinuous curvilinear lines of Art Nouveau and the stylized floral patterns of William Morris are examples among many others. Allusion to nature's pattern is more abstract in the carved surface of *Ilseboro Series* chest of J. M. Syron and Bonnie Bishoff (see plate 31). We can feel the ebb-and-flow rhythm as beach sand shapes to the current of the tide or the pattern of nature's contouring of landmasses long ago. The artists eschewed a highly refined surface, leaving instead the surface of the wood in a less finished and more natural state.

Materials and the Making Process

For many artists making furniture is motivated by the mysterious amalgamations that emerge in combining raw material and virtuoso skill. Every act of the crafting process reveals new creative opportunities. Demonstration of mastery is valued for its own sake, evidence of a perfect union of mind, eye, hand, and material. We are awed in response. In spite of so many possibilities for error or the humdrum, a beautiful form is delivered. At the heart of the production process is an exhilaration from the ever-present risk of failure, which increases as the piece progresses.

Textual narrative is inadequate to express what these artists want to convey. Artist and user connect through a way of knowing and knowledge shared through the senses. For example, we cannot fully and precisely articulate in words the character of the silky finished wood of Radtke's cabinet (see plate 24) in contrast to the steely surface of Rose's cabinet (see plate 25), yet our hand readily distinguishes even the most subtle details of the different surfaces. For both maker and user the goal is a beauty based not only on visual effects but on a more holistic experience that unites the process of production, material, skill, purpose of form, and mind in an intensely arresting object. And integral to that beauty is reaffirming the relationship among nature, maker, and user through privileging the material.

This is not simply revering handmade versus machine-made objects; as David Pye suggests, the hand/machine dichotomy is a false one.[13] All objects are made with tools, some as simple as a hand-held saw, others as complex as a machine programmed to cut a hundred drawers an hour. The discriminating quality is rather the intensity of involvement of the artist in the conception and construction process, the interaction of mind, hand, tool, and material.

An influential precedent for this approach is American Shaker furniture of the late eighteenth century (figure 11). As Shaker craftsmen simplified a form seeking its perfection, they were simultaneously carefully

Figure 11. Shaker, possibly Canterbury, New Hampshire, Sewing Desk, 1875, maple, 38 1/2 x 17 3/8 x 23 5/8 in. Milwaukee Art Museum, Gift of Friends of Art, M1969.30

crafting a visible manifestation of a moral contract to aspire to a perfect life. For contemporary artists the aspiration has shifted from spiritual to reverential in nature. The process of making has a meditative quality in the selection of wood, revelation of the form, and attention to crafting. Artists such as Tom Loeser, Charles Radtke, and Kristina Madsen pursue a similarly reductionist refinement of form. Their pieces radiate a virtuosity resulting from perfectly executing the smallest of details and resisting the addition of anything more. However, this search for perfection is not merely for aesthetic and functional specifications but to focus on a particular dimension. Madsen pursues intricacies of pattern (see plate 17), and Loeser explores overlapping multiple functions (see plate 16).

Wood has been the preeminent material for furniture for millennia. As a rare and thus valuable commodity, it was used sparingly, and to achieve maximum visual impact it was often elaborately ornamented. Even after it became readily available, wood retained favored status through centuries, because of its strength and malleability with a minimum of tools. Jere Osgood (see plate 21) continues this tradition by crafting unusual woods such as bubinga, wenge, and Ceylonese satinwood, so that the beauty of the wood is the expression of the piece. Based on the graceful French bonheur-du-jour desk (see figure 6), Osgood refines the structure to a composition of long, languid, curvilinear lines and silhouettes. It is minimal in mass, with a contoured lid so thin it suggests the translucence of a shell in sunlight. In contrast, *Logged On* by James Dietz (see plate 5) uses wood in a more unaltered state, fresh from its source as a tree in the woods. The contrast between the highly refined finishing techniques used on the drawer and back, and the rough bark that retains its identity as a truncated tree, reveals the range of expressive potential of wood.

Although wood remains a premier material for furniture, others push the boundaries, experimenting with unexpected materials and techniques. An appeal of such materials is the creative freedom they automatically confer. A new material inspires new possibilities for form simply due to the absence of precedents to follow. Brian Gladwell has experimented with cardboard, a material so ubiquitous in our everyday world we rarely consider it for something of permanence and value, but *Console Table with Drawers* (see plate 9) proves otherwise.

Comparison of three cabinets of metal provides glimpses of the incredible versatility and expressive potential residing untapped within various metals, another mundane material. Charles Swanson's *Open-Ended Series #4* (see plate 30), Wendy Wiesner's *Caged* (see plate 35), and Jim Rose's *No. 99 One-Door Cupboard* (see plate 25) are similar in type, vertical proportions, and having one full-length door. Yet despite these features in common the pieces are expressively diverse. Swanson's cabinet of plaster over a metal frame rests heavily on the ground, the passage of time recorded on its surface by the shadow of rust from the frame. Wiesner's cabinet also begins with a metal frame, yet the presence of the two pieces is poles apart. Wiesner's case obviates the weight of the material with a visual fragility opposite to our expectations for the material. The case appears to catch the wind like a full sail. Jim Rose's cabinet recalls old-fashioned ver-

nacular pine-paneled cabinets valued for their dim cavernous interiors. But the image dissolves when our hand touches, not the wood of memory but cold hard steel, a modern material as central to our time as wood in earlier times.

Stepping back from the individual pieces in the exhibition, what do we conclude about these contemporary studio furnituremakers? First, these artists insistently prompt us to rethink our definition of furniture. Most furniture that populates our everyday lives exists in the background; it comes into focus when it does not do well what we intend it to do, e.g., the sofa that sinks too low to permit easy exit. In contrast these pieces are always in the foreground with an expressive presence that demands our attention. They nudge us to think about how a case might function, what it reveals about us, the artist, our culture and time, how we define beauty, what amuses us.

Second, although very much of the present, the pieces are also connected to an innovative and enduring tradition of furniture design and make a unique contribution to it. In the past furnituremakers were motivated primarily by a search for a new formal aesthetic to reflect the time and taste. These furniture artists go beyond rethinking style to exploring the conceptual expressive potential of this utilitarian object, seeking to create objects that arrest us both intellectually and as virtuoso works. Yet the nature of the case as a functional object remains integral to the idea expressed.

And last, as with all furniture, we feel connected to these cabinets and cases in an intimate way, which is our gateway into their messages. As they fascinate and illuminate, we experience those sensations in relation to our physical selves. We have common ground with each piece through expecting to experience each physically. We have experienced such forms in the past—our dresser as a child, an impressive mahogany sideboard in the dining room, and it is this vast experience with furniture that we bring to these pieces. These artists use that foundation and urge us to go beyond into new case piece territory.

Virginia T. Boyd is cocurator of this exhibition and professor in the Department of Environment, Textiles and Design at University of Wisconsin–Madison.

Notes

1. I am indebted to two sets of people. The first includes the artists and makers who so generously opened their worlds to me. The second is the staff of the Elvehjem Museum of Art, all of whom, at various critical points in a long gestation, kept energy and enthusiasm for the project, which I greatly appreciated. I am grateful to all.

2. Changing definitions of such objects with respect to terms including design, art, utilitarian, craft, conceptual, decorative art, and others are reconstructed by Peter Dormer, *The Culture of Craft* (Manchester: Manchester University Press, 1997) and Edward Lucie-Smith, *The Story of Craft: The Craftsman's Role in Society* (Ithaca, NY: Cornell University Press, 1981). Such emphasis on definitions serves primarily to separate and isolate makers and products into arbitrary camps. A more energizing approach suggests a new aesthetic landscape without predetermined borders, open to melding and blending among concepts and categories by the makers who experiment with them, as discussed by Richard and Susan Roth, editors of *Beauty is Nowhere: Ethical Issues in Art and Design* (Amsterdam: G + B Art International, 1998). This approach provides unfettered opportunity for new ways of thinking about kinds of aesthetic activity and objects that reflect and express our time and place. It suggests a new perception of value for objects based on their presence and power to arrest one's thinking and feeling rather than on the category to which they are assigned. Contemporary studio furniture is at the heart of this new aesthetic landscape.

3. Juhani Pallasmaa, *The Eyes of the Skin* (London: Academy Editions, 1996).

4. Gerald Ward, *American Case Furniture* (New Haven: Yale University Art Gallery, 1998).

5. Gaston Bachelard, *The Poetics of Space*, trans. Maria Jolas (New York: Orion Press, 1964).

6. Peter Dormer, *The New Furniture: Trends + Traditions* (New York: Thames and Hudson, 1987).

7. Peter Dormer, *The Meanings of Modern Design* (London: Thames and Hudson, 1990).

8. Gloria Hickey, ed. *Making and Metaphor: A Discussion of Meaning in Contemporary Craft* (Quebec: Canadian Museum of Civilization/Institute for Contemporary Canadian Craft, 1994).

9. Danny Birnbaum, communication with the author, August 24, 2001.

10. Martin Eidelberg, ed. *Designed for Delight: Alternative Aspects of Twentieth-Century Decorative Arts* (New York: Flammarion in association with Montreal Museum of Decorative Arts, 1997).

11. Oleg Grabar, *The Mediation of Ornament* (Princeton, NJ: Princeton University Press, 1992).

12. Meyer Shapiro, "On Perfection, Coherence, and Unity of Form and Content" in *Uncontrollable Beauty: Toward a New Aesthetic*, ed. Bill Beckley (New York: Allworth Press, 1998).

13. David Pye, *The Nature and Art of Workmanship* (London: Cambridge University Press, 1968).

Catalogue

Russell Baldon

Plate 1
Time Capsule, 1995
Wood, steel, mirror
72 x 36 x 30 in.
Collection of Douglas A. Simay

Although it may not be immediately self-evident, Russell Baldon's *Time Capsule* is a self-portrait. The mirror at the top meets the viewer head-on, like a vanity, and the case beneath—essentially, a large toolbox on wheels—is a metaphorical body. Baldon filled the topmost cavity of the chest with various personal effects, photos, news clippings, and the like. He secured these artifacts behind a panel (itself affixed with tamper-proof screws) and left instructions that the contents not be revealed for one-hundred years. This gesture grows out of the awareness that many furnituremakers have of their work's permanence, and the narratives it accrues over time. Baldon says he simply wanted to "kick-start the history" of his creation. But on a deeper level, the piece is a metaphor of the artist's desire to outlive himself through his work.

G.A.

Garry Knox Bennett

Plate 2
Black Buffet, 1994
Ebonized walnut, PVC, paint, 53 x 85 x 14 in.
Collection of Stephen Dubin and Mary Chin

In Garry Knox Bennett's furniture, drawers of unlikely shape appear in unexpected places, and cartoonish forms billow up haphazardly behind luxuriously smooth table surfaces. Bennett finds his compositions by working spontaneously with a power band saw, resorting to hand tools only in the final finishing. Throughout this process, he works quickly rather than meticulously. "There's no labor of love here," he says, "'cause I don't love labor." This rapid invention is especially pronounced in his benches and case pieces, which are as much graphic design as studio furniture. "When I put a piece on the floor, I mostly look at it from the front," he says. "I'm almost not concerned with how it looks end-on because I'm assuming it's going up against a wall. I look at it as a line drawing." Yet some of Bennett's most compelling compositional inventions are also entirely functional—like the cantilevered drawer and pyramidal candlestand in this buffet.

G.A.

Andy Buck

Plate 3
Broom Cabinet, 1992
Ash, milk paint, copper, bristle
73 x 19 x 12 in.
Collection of Dr. Eli and Judith Lippman

Although Andy Buck suffuses his furniture with whimsy, he simultaneously presents ideas about everyday rituals and objects of these rituals. Buck transposed the utilitarian household tool into an agent for communicating cultural values. By encasing a modest broom, he called attention to what is lost in everyday life through the hectic pace. The act of opening each of the doors stops our rush and creates a ritual time to regard such mundane activities at the heart of life. Buck works on the boundary between utilitarian objects and objects for reflection. This piece of furniture speaks about ourselves and our world. When open, the lower door serves as a dust pan, perhaps to sweep up and out of sight those nagging thoughts about what we are ignoring in life as we gird ourselves to face another hectic day. *Broom Cabinet* is concerned with cleaning out both physically and psychologically.

V.T.B.

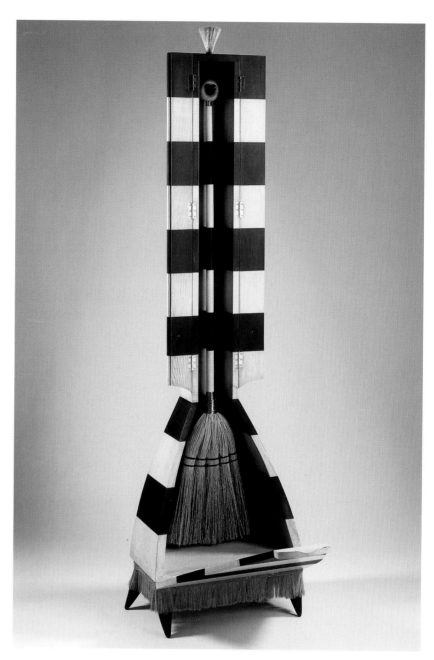

John Cederquist

Plate 4
Tubular, 1990
Baltic birch plywood, Sitka spruce,
maple, epoxy resin inlay,
aniline dye, oil-based litho inks
84 x 48 x 16 in.
Collection of Robert and Gayle Greenhill

It has been frequently been said of John Cederquist's furniture that it embodies the spirit of southern California. This imposing case piece is no exception, with its allusions to surfing and Japanese art (specifically, Katsushika Hokusai's famous woodblock print *The Great Wave off Kanagawa*). More important, however, the piece demonstrates the ingenious use of façade that is Cederquist's key contribution to studio furniture. In his work the relationship between exterior image and interior volume is always dynamic, so that one is hard pressed to predict where and how a drawer will emerge. The playful manipulation of expectations suggests the ambiguity of the relationship between furniture's decorous appearance and its quotidian utility. This is spelled out in the construction of *Tubular*—which is not unlike that of a colonial high chest with expensive figured mahogany veneers and an interior of cheap pine. Behind Cederquist's elaborate false front, one finds only simple plywood boxes.

G.A.

James Michael Dietz

Plate 5
Logged On, 1995
Maple and cherry
36 x 16 x 18 in.
Collection of Marena C. Kehl

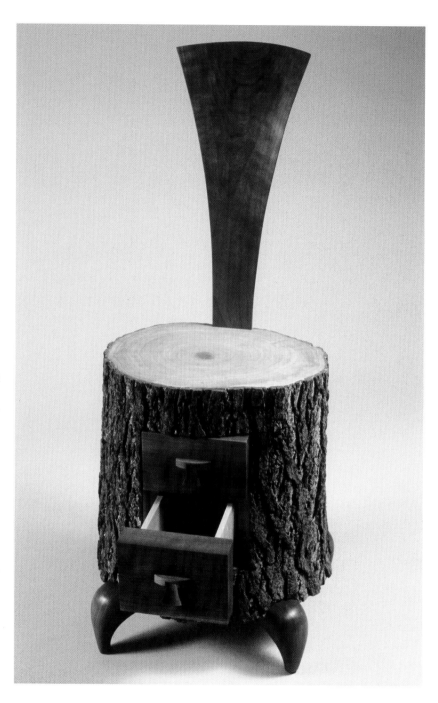

There is a long tradition of furniture that uses wood in its original state, such as rustic Adirondack twig furniture. Jim Dietz contrasts wood's natural rough character with its refined state to emphasize the starkly different characteristics of each. The meticulously crafted whale-tail back support and diminutive drawers with tiny whale-tail pulls have the smoothness and richness of fine wood finishing, in sharp contrast to the rough, gnarly bark. The hollow pulls respond with a distinctive tone when tapped against the case on opening and closing, like the resonance from the cavity of a wooden musical instrument. Inspired by everyday utilitarian African wooden stools, the piece, intended to be used, is surprisingly comfortable. The work presented difficult technical challenges to accommodate the unstable behavior of the continuous expansion and contraction of the log that surrounds the stable wood of the drawers and attached parts.

V.T.B.

John Dunnigan

Plate 6
Twin Cabinet, 1997
Cherry, brass
84 x 48 x 24 in.
Private collection

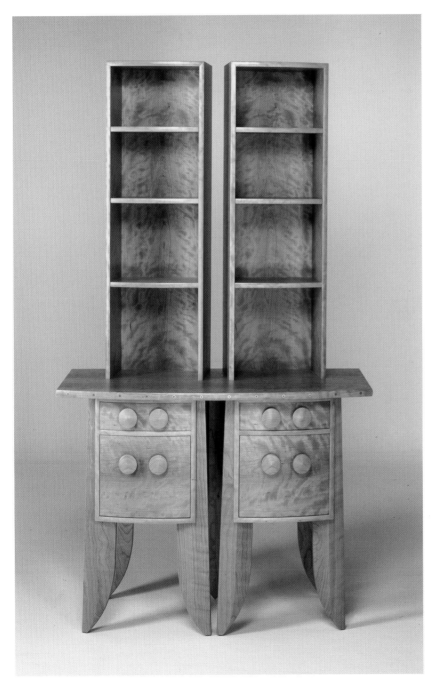

Twin Cabinet is about duality within unity. Each base cabinet and the shelves above are independent entities, the space between reinforcing their independence. The base cabinets even face away from each other, cementing their separate natures. Yet the two make a single whole, connected by a slight but binding horizontal plane. The metaphor of duality in the piece reflects its owners. The piece was designed to meet the needs and tastes of a couple: separate individuals with differing tastes yet committed to a single piece reflective of both. John Dunnigan's work for the clients over many years has resulted in a mutually satisfying collaboration, the furniture linking maker and user, while expressive of both. Dunnigan is particularly conscious of how the furthermost edges of a piece meet the space around it. In this case that outermost edge is noted with a delicate band of inlaid brass circles.

V.T.B.

Bradley P. Engstrom

Plate 7
10,000 Dreams, 1999
Basswood and pastel
54 x 25 x 12 in.
Collection of Mr. and Mrs. Jerome A. Kaplan

Brad Engstrom's case is overtaken by a pointillist surface. Thousands of tiny notches with triangles of color cover every inch of surface. The color is recessed within each notch, which deepens its intensity and produces a confettilike riot of color and flicker of tiny planes. Yet the extensiveness of the repetition creates an undercurrent of relentless resolve and stamina. The thirty-two drawers and five hidden compartments of the interior explore complexities of the deepest, greatest, and most elusive of human sentiments, that of love. A page from an old Funk and Wagnall's dictionary with the definition of this ineffable word resides deep inside. The fragmented images from the crazed and mica mirrors reflect our narcissistic instincts yet inability to see ourselves clearly. Unfinished, naked interior surfaces imply the unfinished business we carry within.

V.T.B.

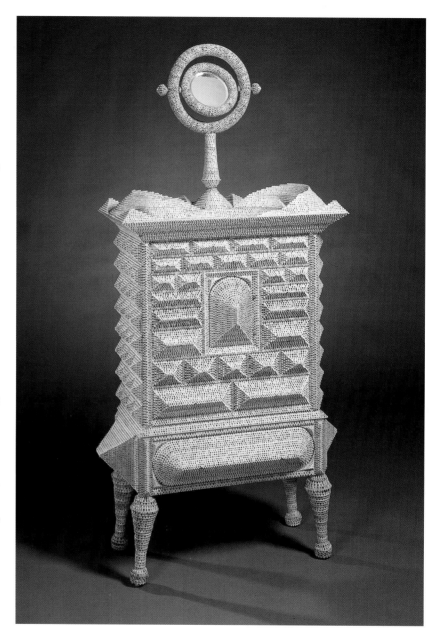

Christine M. Enos

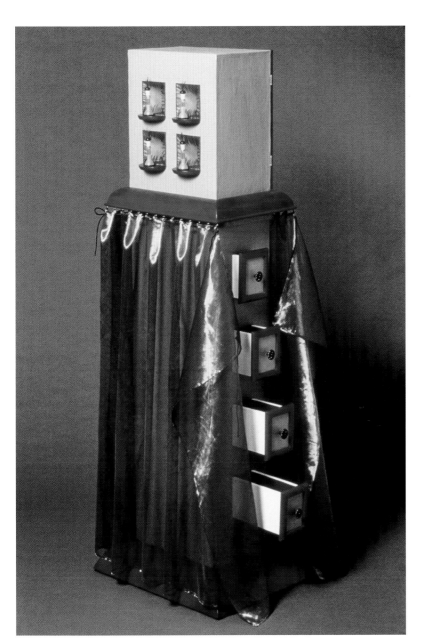

Plate 8
Perfume, Potions, and Poisons, 1998
Wood, fabric, paint, mixed media
60 x 18 x 15 in.
Courtesy of the artist

Perfume, Potions, and Poisons explores technical and conceptual domains. With it Enos expanded her range of materials and surfacing techniques, covering the plywood frame with skins of plaster and then painted fabric. I used "skin" deliberately, because its form suggests a woman's torso and trunk. The piece conceptually expresses the way the self opens out to the world in all directions—as do the drawers and doors, yet from a secure and comfortable foundation—the case. Open the doors and you find tiny bottles for perfume and poison, the pleasures and pains to which we expose ourselves. Enos's recent work spans pieces both predominantly functional in nature in which the user invests his or her own identity, and such conceptual work as this that expresses dimensions of Enos's own identity.

V.T.B.

Brian Gladwell

Plate 9
Console Table with Drawers, 1989
Cardboard, lacquer, pigment, flocking
34 x 35 x 17 in.
The Saskatchewan Arts Board
Permanent Collection
Photo by Don Hall

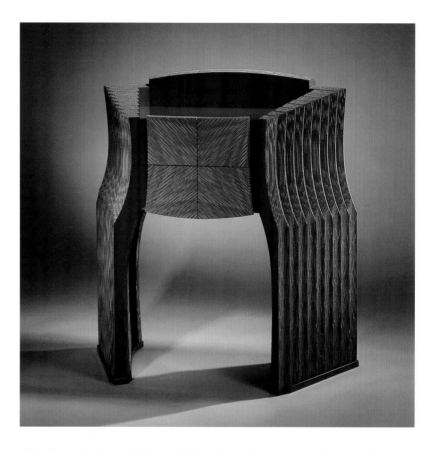

"Cardboard and wood," Brian Gladwell says, "are quite similar to each other structurally. They both have long hollow tubes inside them." This unusually shaped console table is a product of Gladwell's investigation into this insight. It relates to a wooden version he made of a similar form, which has distinctively shaped legs that shoot straight up from the floor and then curve to meet the side of the case. For the cardboard version, he repeated this motif along the table's flank, in the process creating a pattern akin to wood grain. Similarly, the fronts of the drawers on the piece's façade are cut to produce a "figure" reminiscent of a veneer. These compelling surfaces cause some confusion in the viewer—certainly, they are not immediately recognizable as humble cardboard—and this speaks to Gladwell's professed interest in working with this unusual medium, "devoting intelligence, time, and intensity to a material that we don't normally associate with those qualities."

G.A.

Jenna Goldberg

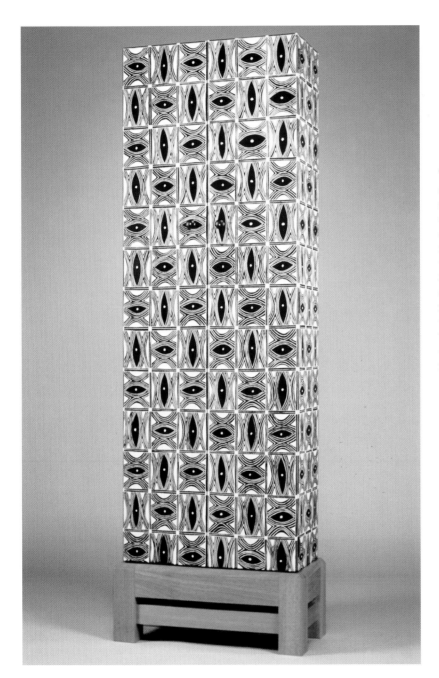

Plate 10
Entry Cabinet, 1999
Carved and painted basswood
73 x 24 x 12 in.
Private collection

The contrast between the interior and exterior of case forms is rarely more sharply drawn than in this tall, boldly decorated cabinet. The façade is decorated like a grid of stylized eye forms (symbolic, as the artist notes, of the "window of the soul"). The inside is embellished with a pattern of wheat stalks executed in a soft palette, redolent of nineteenth-century wallpapers. The combination suggests that the cabinet is, like the wardrobe of C. S. Lewis's novels, a point of entry into another visual world.

G.A.

Patrick Hall

Plate 11
Dance with the False Moon, 1997
Plywood, aluminum, glass,
etching inks, postage stamps
70 x 36 x 18 in.
Collection of Victor and Faye Morgenstern

Tasmania's Patrick Hall creates poetry out of the least romantic of case furniture forms: the file cabinet. Packed with prose and verse inscriptions, found objects, and cast-metal miniatures, Hall's works are dense with content. The words and images do not add up to a coherent narrative but a collage of loose impressions. The conceit that drives his work is that of the file cabinet as a metaphor for the mental space of memory. The functions of storage and retrieval, always imperfect and surprising in one's own consciousness, are complicated in his cabinets by arbitrary (or absent) filing systems and improbably populated interior spaces. Yet the mysterious character of Hall's content is offset by his unusually forceful materials and construction—more evocative of the deluxe technology of a postmodern factory than the traditional pleasures of a hand craftsman's studio.

G.A.

Michael Hurwitz

Plate 12
Rocking Safe, 1993
Ash with bronze ballast,
damascus and gold lock,
cashew finish over papyrus on interior
39 ¹/₂ x 22 x 13 in.
Collection of Wendy Evans Joseph
Photo by Tom Brummett

In 1990, having made significant life changes, Michael Hurwitz spent six months in Kyoto, Japan, where he experienced a sense of being adrift. *Rocking Safe* is about finding safe harbor in the form of a buoy that remains resilient and safely moored. The mix of materials was significant. The elemental materials of papyrus, petrified wood, ash, traditional metal alloys, lacquer, and inlay of gold and silver, connected him to craftsmen in many media. The base of petrified wood suggests different apparent realities. Papyrus paper lining the woven basket evoked biblical Moses, protected in a basket hidden in bull rushes. A lock based on three discs of an alloy used in ancient swords reinforced personal safety. Materials, form, and controlled kinetic energy together weave a web of delicate strands of connection to traditions that provide stability and safety.

V.T.B.

C. R. "Skip" Johnson

Plate 13
Overturned Ore Car, 1982
Oak, walnut, wenge
45 x 48 x 28 in.
Courtesy of the artist
Photo by H. Koshollek

Throughout much of his career Skip Johnson has explored trompe l'oeil through subjects of contemporary culture. *Overturned Ore Car* demonstrates his use of illusion. In this homage to lost friends, Johnson tells of the accident of a miner whose car brake fails, plummeting the car forward, breaking the axle and overturning the car and contents. The broken brake, bent axle, eroded frame as the miner tried to slow the car document the tragedy. Using barn siding to create the worn wood of the car and wenge to simulate metal angle irons contribute to the illusion. Opening the cabinet with the broken brake handle reveals an interior polished and refined with the most meticulous details of traditional cabinetmaking. Shelves and fittings hold glasses, bottles, and the accouterments of a bar prepared for a pleasant social evening.

V.T.B.

Kimberly Kelzer

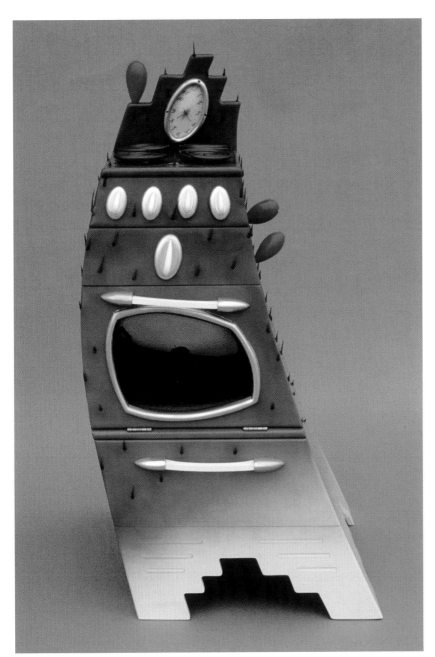

Plate 14
Home on the Range, 1991
Wood, aluminum, neon,
Plexiglas, rubber, Corian
36 x 22 x 20 in.
Collection of Gail M. and Bob Brown

Home on the Range began with an ornamental metal plate pried from a stove abandoned in the desert. Kitchen Made or Maid? Kim Kelzer makes things in wood; she says things in wood. She worked on this when she had decided to pursue her own future, rejecting social expectations. Some people viewed her as remaining a child playing with a toy stove, not becoming an adult woman in command of the kitchen. Kelzer's range assumes one of the desert forms—the tough prickly skin of a cactus. The work was difficult to construct because nothing is square; numerous forms curve in two directions. Details required mastery of anodized aluminum, Corian plastic, slubbed Plexiglas, and neon, in addition to techniques of fine cabinetry. The mastery suggests a coming-of-age in her chosen field.

V.T.B.

Silas Kopf

Plate 15
Typewriter Desk, 1987
Mahogany, satinwood, and marquetry
46 x 51 x 22 in.
Private collection

Among the most difficult arts in woodworking is marquetry—the construction of images using interlocking pieces of veneer. A typical marquetry picture might contain hundreds of these fragments, each of which must be individually shaped. America's leading practitioner of this demanding craft is Silas Kopf, who was trained at the École Boulle in Paris. In this desk, Kopf draws on the long European tradition of trompe l'oeil marquetry. The colors of the depicted objects on the fall-front desk are all those of the natural wood, with some pieces shaded with careful burning in hot sand. The illusion, more striking in the object than the photograph, is positively magical, effecting a collapse of exterior and interior space.

G.A.

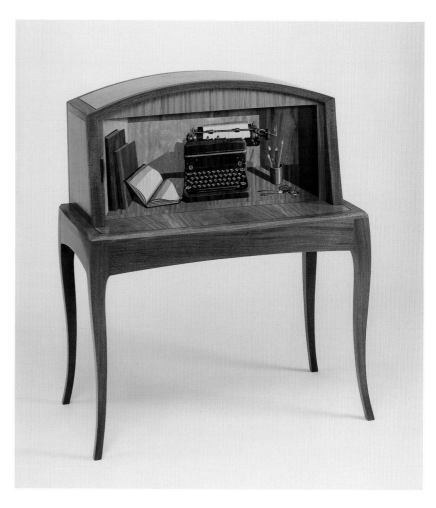

Thomas Loeser

Plate 16
Roller #1, 2000
Fir, maple, mahogany, stainless steel, steel, paint, 20 x 20 x 58 in.
Courtesy of the artist
Photo by Bill Fritsch

Tom Loeser's rolling blanket chest reflects his longstanding preoccupation with motion in furniture. It is an inversion of the form's typical configuration: here, the box moves while the lid stays put, propped up by a freestanding leg. It also doubles as a bench, a usage signaled by the painted semicircular depressions in the chest's lid. Thus the piece conforms not only to a chest's proper function as a receptacle, but also to the ancillary functions it takes on daily as a table or as seating furniture. In addition, the piece's outward swinging motion adds an assertive note that suggests discontentment with the passive role of a standard wall-bound blanket chest. In these respects, the piece is typical of Loeser's work; it is a drastic alteration of a familiar form that asks us to reconsider that form's usual properties.

G.A.

Kristina Madsen

Plate 17
Cabinet on Stand, 1998
Bubinga, dyed pearwood, ebony
48 x 32 x 14 in.
Collection Sheila and Eugene Heller

The work that brought Kristina Madsen to national prominence was an outgrowth of her stay in Fiji, where she learned the traditional craft of patterned chip-carving. During this experience, she acquired both technical facility and an appreciation of the visual dynamics of densely faceted surfaces. This cabinet is a departure from the motifs of Pacific carving into a nonrepetitive calligraphic pattern reminiscent of abstract expressionist painting. The surface is carved to two different depths: in some areas, Madsen carved through a blue veneer to reveal the red color beneath; in others, she executed more shallow cuts that stay within the thickness of this blue veneer. The result is a shimmering façade that seems to shift before one's eyes as it reflects the light. Madsen sets this complex optical event within a relatively plain neoclassical cabinet, so that the form does little to distract from the ornament.

G.A.

Wendy Maruyama

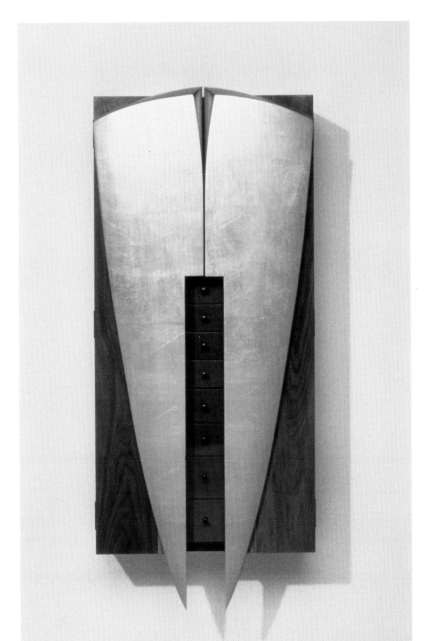

Plate 18
Peking, 1996
Polychromed mahogany, gold leaf
54 x 24 x 10 in.
Collection of Stephen and Susan Weber

Peking includes elements of Wendy Maruyama's now distinctive formal vocabulary: outsized abstract sculptural forms attached to boxy, angular cabinets and lush, deeply saturated colors painted on smooth, contoured surfaces. However, using the same vocabulary, for example, rounded forms, she imagines a wide range of expressions. This lustrously gilded, bisected shield promises a stately ritual as one opens wide the two large doors. The process of opening has a consciousness and import that opening the kitchen cupboard can never hope to achieve. One feels privileged to enter. When the doors are fully opened, the almost square proportions and crisp angular features and details give faint echo of silken robes with deeply cut sleeves extended and Asian lacquered cabinets with burnished bronze hardware. The power, silence, and serenity of *Peking* imply secular sacred places.

V.T.B.

Alphonse Mattia

Plate 19
Cyboard, 1993
Asian marble wood, ebonized mahogany, satinwood
41¹/₂ x 74 x 22 in.
Collection of Diane and Marc Grainer

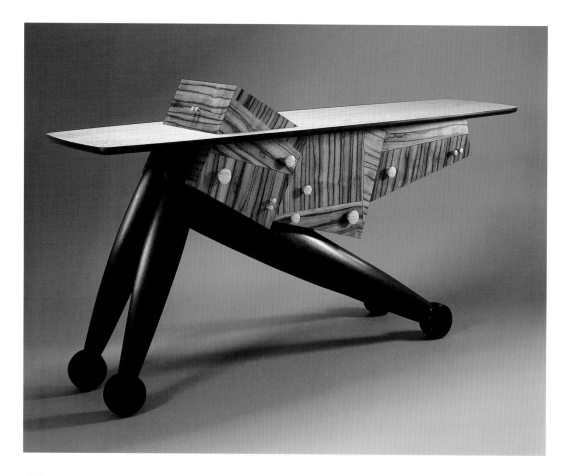

Alphonse Mattia probably could not be conventional even if he wanted to be. His pieces often seem blithely out of whack, slightly (or mightily) skewed, delightfully disordered, precariously balanced. He describes *Cyboard* as a functional sideboard, with drawers for storage below and a letter box for writing materials and the stray car key and such on top. But that surely misses the main point. *Cyboard* suggests an ordinary ironing board at home in the laundry room, dressed up in fine veneer and puffed with pride at having been asked to sit in the living room. Mattia's pieces have an energy that comes from a sense of impending change: The board may collapse, scattering drawers in a heap. The parts are in suspension, not quite settled into a stable whole, teetering on dissembling into a pile of parts.

V.T.B.

Judy Kensley McKie

Plate 20
Ribbon Cabinet, 2000
Carved mahogany
$50^{1}/_{2}$ x $19^{1}/_{2}$ x $5^{1}/_{4}$ in.
Collection Anne and Ronald Abramson
Photo by Dean Powell

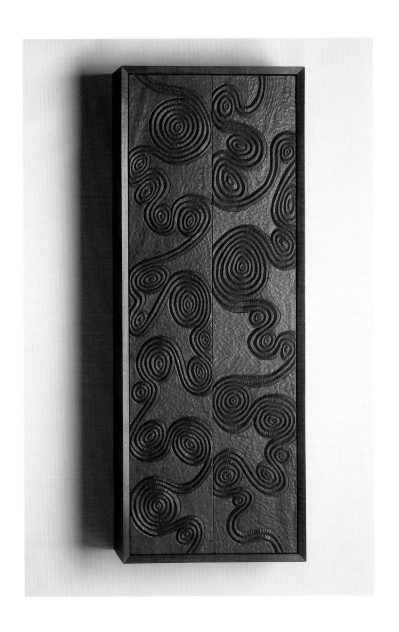

Judy McKie is particularly known for furniture reminiscent of a wild and fanciful animal kingdom come alive. *Ribbon Cabinet* displays a different side of McKie's imagery and carving, focusing on graphic, decorative surfaces. Earlier in her work such intricately carved and abstractly patterned fields provided the ground for animals and plants. Gradually the ground disappeared, and fantastical animals and plant forms emerged as three-dimensional sculpture inhabiting the structures and spaces of furniture. Here, she plays with a single ribbon motif with varying lengths of springy ribbon unwinding and falling randomly over a surface. The curvilinear character of the motif is echoed in the rounded edges of the raised frame around the door panel and the slightly rolling, uneven field. Together the elements of the surface pattern create an energy. Such decorative two-dimensional surfaces are perhaps founded on McKie's very early work with pattern in textiles and fibers.

V.T.B.

Jere Osgood

Plate 21
Summer 99 Shell Desk, 1999
Bubinga, wenge, Ceylonese satinwood,
 leather, brass
44 x 43 x 33 in.
Collection of Museum of Art,
Rhode Island School of Design,
Providence, Helen M. Danforth Fund, 1999.30
Photo by Dean Powell

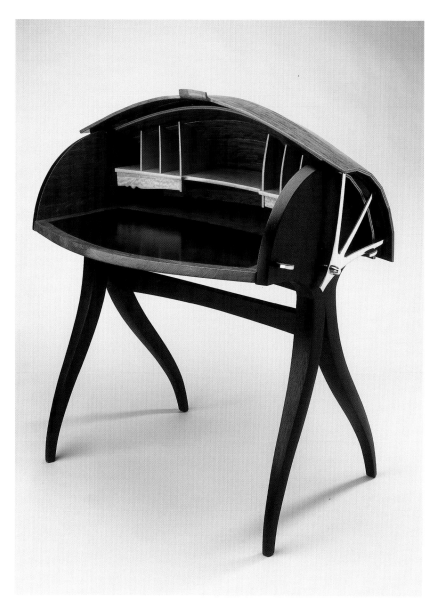

Jere Osgood, one of the elder statesmen
of studio furniture in America, is the
field's foremost authority on difficult
shaping techniques such as compound
bending and tapered lamination. Both
of these processes are demonstrated in
this piece, which is one of a series of
shell desks dating back to 1970. In its
subtle control of line, the desk may
seem superficially similar to the
furniture of such precursors as
Wharton Esherick and Sam Maloof.
But Osgood's work is the product of
preplanned jigs, not the extensive
hand-shaping employed by earlier
makers. The slats that compose the
sliding cover on the desk are made like
barrel staves—profiled and bent to fit
perfectly into a gently swelled dome.
Each of the desk's legs is shaped from
a sandwich of thin layers of wood;
each layer thickens gradually towards
the top of the leg. This laminated
structure is then steam-bent in a press
mold, so that the whole element curves
and tapers simultaneously.

G.A.

Emi Ozawa

Plate 22
Seesaw 2, 2001, Apple plywood, acrylic paint, 9 x 19 ¹/₂ x 8 in.
Four Quarters, 2001, Cherry, acrylic paint, milk paint, rear earth magnet, 9 x 9 x 3 in. (closed)
Pendulum Box, 2001, Poplar, brass, acrylic paint, 9 ¹/₂ x 4 ¹/₂ x 5 ¹/₂ in.
Quack-Quack, 2000, Apple plywood, cherry, milk paint, acrylic paint, 13 x 17 x 5 in.
Half Moon, 1999, Mahogany, 3 ¹/₂ x 7 x 3 in.
Courtesy of the artist
Photo by Mark Johnston

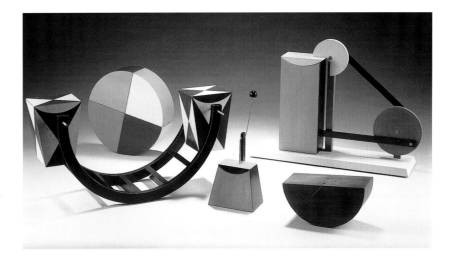

Emi Ozawa began as a sculptor who wanted people to touch and interact with her sculptures, which were strong enough to accommodate such intimacy. Furniture provided these potentials. Yet still attracted by formal abstraction, Ozawa experimented with abstract ideas and processes through the forms of furniture. She thinks about the form of a box, exploring ways of opening and closing it. Her goal is to focus on the transition from closed to open, not to reveal what is inside. She uses levers, pendulums, and forms that move in response to gravity or a slight nudge, to extend an action and dramatize the process of opening. There is often a kinetic component to her pieces, created through clockworklike gears and simple mechanisms. A long interest in toys and boxes has come together in her current work, which is increasingly smaller in scale, moving away from furniture toward diminutive forms with motion.

V.T.B.

Gordon Peteran

Plate 23
Ark, 2000
Oak, glass, crushed velvet
72 x 48 x 24 in.
Collection of the artist
Photo by Doug Hall

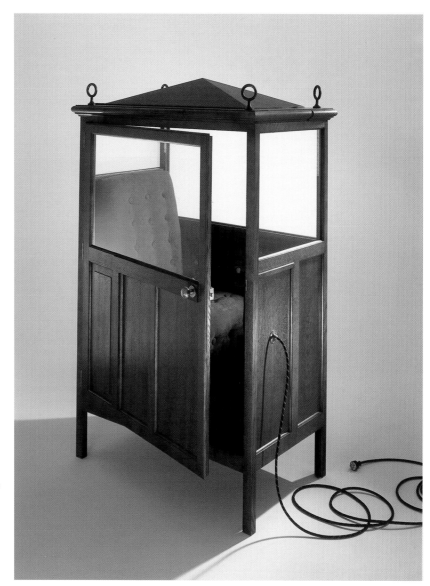

Gord Peteran's *Ark* is as much about display as it is about containment. The primary historical precedent for the piece is the specimen cabinet, familiar from natural history museums that display botanical, zoological, and anthropological samples. *Ark* marries this pseudo-scientific furniture form with seating furniture types—a throne or a carriage, perhaps—resulting in a specimen cabinet for a person. The atmosphere of disquiet begins with the exterior joinery of the cabinet, which is composed of panels that tilt at unexpected angles, each one with a slightly different configuration of slanted framing elements. The sinister tube that slithers away from the piece is in fact an electrical cord. It powers a light that is activated when someone sits down inside the piece and closes the door. When in use, the *Ark* becomes a double-edged metaphor that suggests both luxury and death, exhibitionism and claustrophobia.

G.A.

Charles Radtke

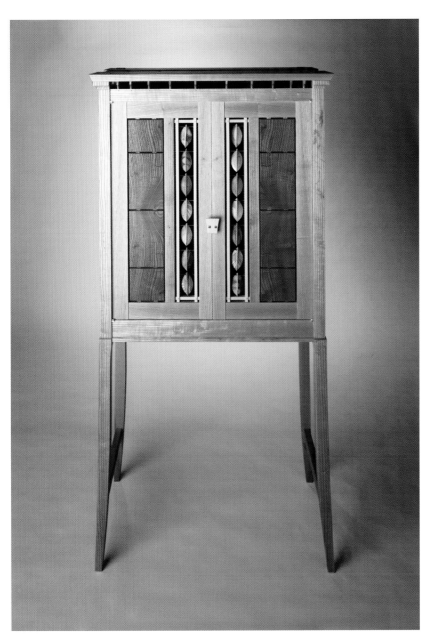

Plate 24
Leaf Cabinet, 2001
Ash, sassafras, holly,
enameled fine silver by artist Sarah Perkins
57 x 31 x 17 in.
Collection of Tom and Diane Heyrman

In a field heavily populated with skilled craftspeople, few makers attain prominence primarily for their exquisite technique, but Charles Radtke is one who does. His furniture stands out from a crowd of similar (but more pedestrian) work because of its discipline. Radtke has brought to its logical conclusion the furniture lineage that began with the cabinets of James Krenov: an almost excessive concern with wood selection; uncanny precision in the hand-shaping of curved elements; lovingly applied finish; and above all, a restrained design sensibility that quietly rejects the more strident styles common in studio furniture. Yet for all its refinement, Radtke's work never seems finicky or calculated; rather, the craftsmanship serves as a backdrop for a formal conceit. In this case, the subject is an interplay of interior and exterior space, signaled by the reveal underneath the top, and the floating panels and enameled silver leaves that partially mask the apertures in the case front.

G.A.

Jim Rose

Plate 25
No. 99 One-Door Cupboard, 1999
Steel with natural rust patina
73 x 29 ³/₄ x 22 in.
Courtesy of Ann Nathan Gallery, Chicago, IL

Jim Rose is interested in how furniture functions for users and how it addresses its purpose. He studied the way American Shaker design expressed values through furniture as a way of talking through his own work. For Rose, as for Shaker craftsmen, the process is not simply meticulous joinery and finishing, but a contemplative act of an ethical commitment to certain life values. That sensitivity is best illustrated in his choice of material. Because his designs reflect wooden Shaker forms, we expect his work to have the texture and warmth of wood. His cabinet surprises us with the cool, hard surface of steel. Rose uses scrap metal, keeping the surface he finds, using no chemical intervention to make minimal impact on the natural environment. This cupboard is made of one large flat sheet with the exception of the door panels, the contrast creating the illusion of different woods.

V.T.B.

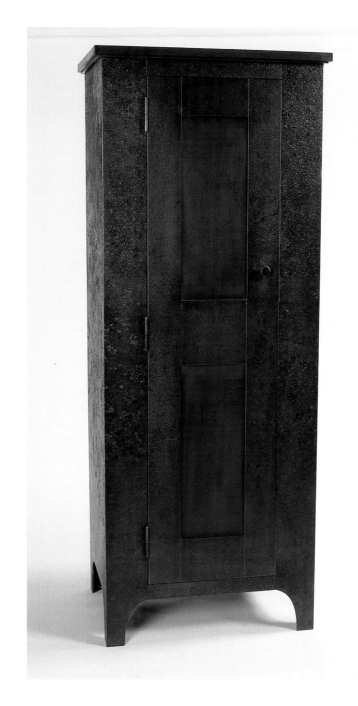

Mitch Ryerson

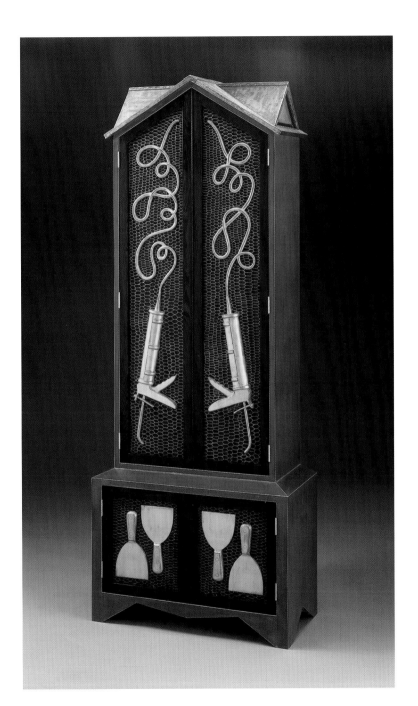

Plate 26
The Handyman Special, 2000
Wood
68 x 27 x 13 in.
Courtesy of John Elder Gallery, New York, NY
Photo by Dean Powell

A handyman's world is a house. As Mitch Ryerson demonstrates, the step from house to armoire is short. A cabinet as house is reenforced through a double-gable top/roof and real lead flashing. This house celebrates, perhaps exalts, the often maligned and certainly underappreciated cadre of fixers in our midst. Trooping on, their hours and days are recorded in the worn edges exposing the frame through the milk paint, the patina of a much-used tool chest. Yet in this cabinet the handyman is given his moment in the spotlight. His tools-of-the-trade take on ceremonial splendor, caulking guns and spreaders leafed in gold. And the surface of the door panels hints that there just might be a new pair of alligator boots for the fifteen minutes of fame that Warhol reserves for us all.

V.T.B.

Randy Shull

Plate 27
Throne, 1999
Painted wood, croquet mallets
36 x 36 x 15 in.
Collection of Sally and Jose Diaz

This wall-hung cabinet is one of a series of pieces by Randy Shull that employs the image of the chair, arguably the most iconic furniture type and traditionally the litmus test of a maker's skill and ingenuity. For Shull, the form is "such a powerful symbol that it's interesting to place it in different contexts, to see if it retains that power." In this case, he has transmuted two chairs into a pair of green swinging doors and framed them in a set of concentric circles. Two smaller white chairs are nestled within the backs of their larger cousins, creating an unsettling visual movement through implied perspective. Each chair is executed in a rigidly geometric style—like the furniture of minimalist sculptor Donald Judd; these read not as particular chairs but rather as abstractions of the concept: chair.

G.A.

Tommy Simpson

Plate 28
Firsts, 1988
Painted poplar with zinc sheets
59 x 38 x 18 in.
Courtesy of the artist

Tommy Simpson's work evokes goodness, neighborliness, and generosity of heart. Such values float behind the works that often seem to be memoirs of simple pleasures, long tranquil sunny afternoons, family and friends. The power of his past in the small towns of the Midwest is manifested in forms that draw on such traditional vernacular furniture as Windsor chairs, four-poster beds, and the fragmented images of happy dreams. Although most viewers imagine rather than remember such a past, the sweetness and delight his pieces elicit testify to the universality of such a vision. *Firsts* recalls the common pie safe with punched tin panels to let air flow as baked goods cooled. Messages punched into the tin connect us with that idyllic past recalling mundane "firsts" such as roller skates, the perambulator, breakfast cereal, and rubber balloons.

V.T.B.

Rosanne Somerson

Plate 29
Father and Child Cabinet, 1995
Chestnut, oak, ivory lacewood
72 ¹/₂ x 24 x 15 ¹/₂ in.
Collection of Diane and Marc Grainer

Father and Child Cabinet is something of an anomaly in Rosanne Somerson's oeuvre. She frequently addresses furniture's role as a focus of daily ritual, but this piece is unusually specific in its references—almost anthropomorphic. It was conceived as a pendant to another piece called *Mother and Child* which, like this one, is a kind of reliquary for a trophy. While the maternal cabinet is centered on this motif, as if around a heart, in this paternal version the trophy is located in the "head," reflecting the intellectual rather than physical nature of fatherhood. Though Somerson and her husband, Alphonse Mattia, did, in fact, become parents shortly before the creation of these pieces, the artist does not see them as portraits but as general reflections on the roles of parenthood. And there is something in this composition—a large cabinet projecting miniature versions of itself upwards and onwards—that seems instantly recognizable as a depiction of the unique dependence and hope of family.
G.A.

Charles Swanson

Plate 30
Open-Ended Series #4, 1992
Plaster with acrylic, steel rod
48 x 12 x 21 in.
Courtesy of the artist

Having used highly intricate wood-working techniques, Charles Swanson looked for a process that was more direct from conception to completion, allowed a high degree of spontaneity, permitted constant creative thinking through production, and ended with a surface that came directly out of the process. In an abandoned steel shopping cart rusting in an alley, he saw potential in combining metal and plaster. This resulted in a series of fourteen, including *Open-Ended Series #4*. He covered a metal grid with a thin surface of plaster, sanded it smooth, and finished it with car wax to produce an effect similar to glazed chalk. As the metal rusts slightly, its shadowy traces emerge through the plaster, recording the passage of time on the surface. Because this was part of a project designing furniture for children, it is child-size in scale. The locker has a shelf for books, hooks for jacket, and place for boots.

V.T.B.

J. M. Syron and Bonnie Bishoff

Plate 31
Ilseboro Series: Small Chest, 2001
Basswood and ash, 22 x 36 x 20 in.
Courtesy of the artists
Photo by Dean Powell

"I love the carving of the Pacific Northwest Indians," says Bonnie Bishoff. "You can feel where every gouge mark went. It makes my fingers itch." This chest, joined together by J. M. Syron and then carved by Bishoff, uses natural wave-forms as the basis for a turbulent, undulating composition that seems ready to overflow the boundaries of the form. Working with a power grinder and then a series of increasingly fine gouges, Bishoff creates a surface topography of dynamically intersecting facets. The piece is one of a series that dates back to 1993, which features similar ornament on forms as diverse as headboards, nightstands, dressers, and a credenza. Each piece conveys not only the tactile pleasures of carving, but also its gradual quality—as if the surface were worn down through a process of slow erosion. Fax copy.

G.A.

Bob Trotman

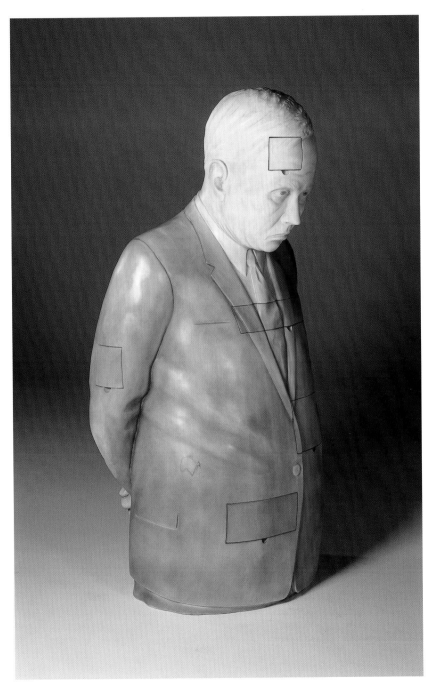

Plate 32
White Guy, 1994
Limewood, drawer mechanisms, paint
64 x 36 x 27 in.
Collection of Dr. Kirby and Pricilla Smith

This is the ultimate compartmentalized man, a file cabinet. Trotman uses the drawer to express nuances about *White Guy's* alienation from much in his world. The various drawers extend through the entire sculpture, the drawer in the arm extends from elbow to elbow, for example. If we could see through to the hollow inside, we would see the several drawers move silently and separately by each other over the years, the contents never connecting, just as the parts of *White Guy's* life remain unconnected. The drawers move on ball bearings, giving the distinctive metallic sound associated with drawers in a metal file cabinet.

V.T.B.

Christopher M. Vance

Plate 33
Staircase, 1998
Wood, paint, glass, lights
75 x 15 x 50 in.
Collection of Helen Hilton Raiser

This chest of drawers masquerades as a free-floating architectural element. Each step in the piece is actually a drawer, which can be opened by pulling on the step beneath. This conceit provides an unusually forceful version of case furniture's domestic resonance. Vance is normally known for tightly constructed studio furniture, but for this piece he employed standard house-building techniques and materials. The homey feel is appropriate for the content of the piece; it was made shortly after the death of Vance's mother and was partially conceived as a tribute to her. The vaultlike space at the top is a lamp, whose light symbolizes her benevolent presence.

G.A.

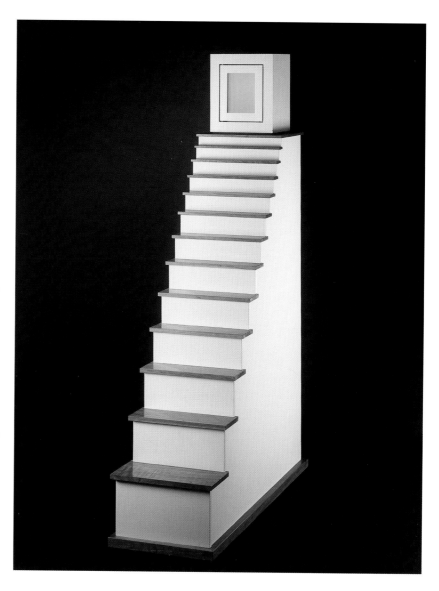

Gayle Marie Weitz

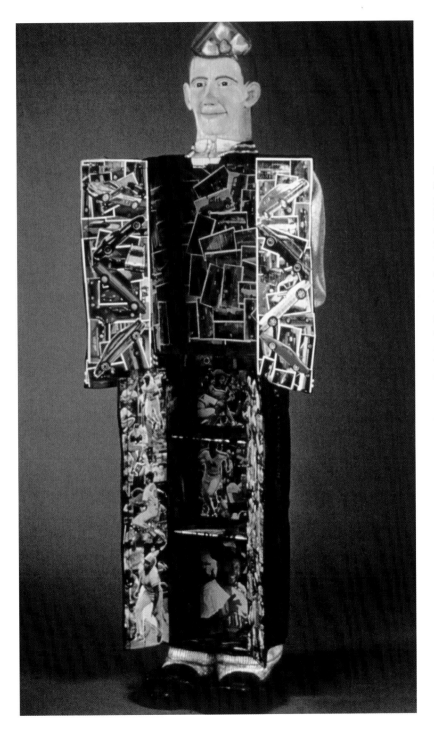

Plate 34
Persona # 9: Teenager
from the series *Social Studies*, 1989
Painted, collaged, carved wood
69 x 22 x 14 in.
Courtesy of the artist

Gayle Weitz believes that long-term social change comes through education. Her art demonstrates her broader commitment by presenting social issues in the forms of familiar utilitarian objects. She challenges our thinking about difficult issues in this everyday nonthreatening environment. *Persona #9: Teenager* is one in a series that explores stereotyping; she sees self-awareness as the first step in eradicating its deleterious effect on society. To complete the piece she had to confront and express her own and contemporary society's stereotypes of "a teenager." Themes such as baseball, cars, and advertisements for women's underwear inhabit the interior psyche space of *Persona #9*. Weitz thinks we each have a particular context of values and beliefs, and to understand a universal "Truth" we must experience as many new contexts as we can. Her work is a path to understanding different contexts and realities.

V.T.B.

Wendy M. Wiesner

Plate 35
Caged, 1997
Wire cloth, steel, ash
72 x 36 x 30 in.
Collection of Beverly Barfield

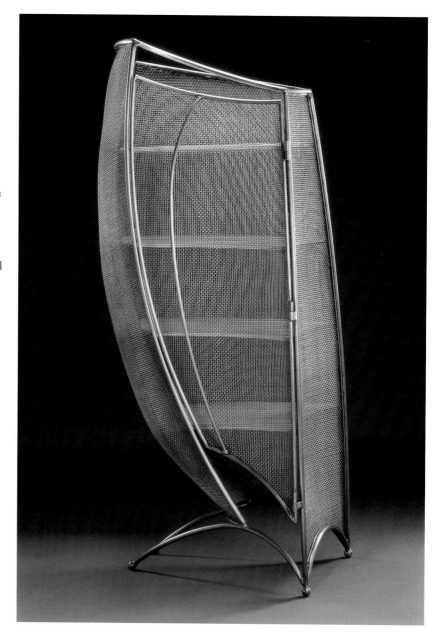

Large case furniture is almost auto-
matically tagged with adjectives such
as heavy, durable, and monumental. In
Caged, Wendy Wiesner introduces a
whole new vocabulary for such
cabinets. Descriptors such as light,
airy, and delicate describe her piece.
She exploits the tensile strength of steel
to form exceedingly slender and long
structural members, few in number to
construct the most minimal yet
sufficient structure. The material also
offers the potential for a fluidly
curving linear formal vocabulary that
Wiesner explores by creating billowing
forms that cantilever over space. Any
surface other than the virtually
weightless wire cloth would sink this
piece. Its gossamer net is enclosing yet
seemingly infinitely permeable. On
viewing *Caged*, one almost holds one's
breath, wondering how so delicately
balanced and framed a structure can
hold even the slightest weight without
failing.
V.T.B.

Brian Wilson

Plate 36
Keeper of Memories, 1994
Polychromed bass wood, steel,
leather, found objects
77 x 46 x 29 in.
Courtesy of the artist

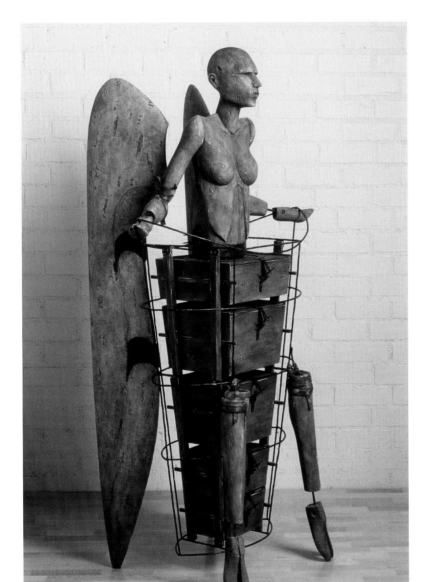

We exist through memories of ourselves and others. Without memory we cannot negotiate daily life. In Brian Wilson's primarily sculptural production, he explores the function of memory. In the drawers of *Keeper of Memories* are objects left as traces of those now gone: shoes, coat hangers, and such, suggesting that the detritus of everyday life keeps memories alive. The top of each drawer is a metal grate and the bottom is glass. Thus we can look down through layers of drawers and objects, much as memory compresses events distant in time and place into a single view, which we see through our current context. Wilson muses that his ideas on memory filter from personal work such as this into his production furniture work in subtle ways, often unrecognizable to others.

V.T.B.

Edward Zucca

Plate 37
Cave Man TV, 1993
Poplar, hemlock, oak, ash, maple, bark,
bark paper, cowhide, paper rush, horn,
bones, chamois, Connecticut fieldstone
74 x 32 x 26 in.
Courtesy of the artist

Although it looks as if it were just
pulled off the set of "The Flintstones,"
Ed Zucca's *Cave Man TV* is a fairly
sophisticated piece of cabinetmaking.
Part of a series of televisions done in
various styles (Shaker, ancient Roman,
and Egyptian), the piece evokes the
wooden cabinets that the artist sat in
front of as a child. Zucca transforms
this everyday icon of pop culture into a
mock paleontological artifact. The
result is an ambiguous object that both
captures the fantasy world inside
television and suggests the surreal
senselessness of this fantasy. As befits
its style, the piece is constructed in
willfully crude fashion, complete with
ornamental bark stripped from
firewood.

G.A.

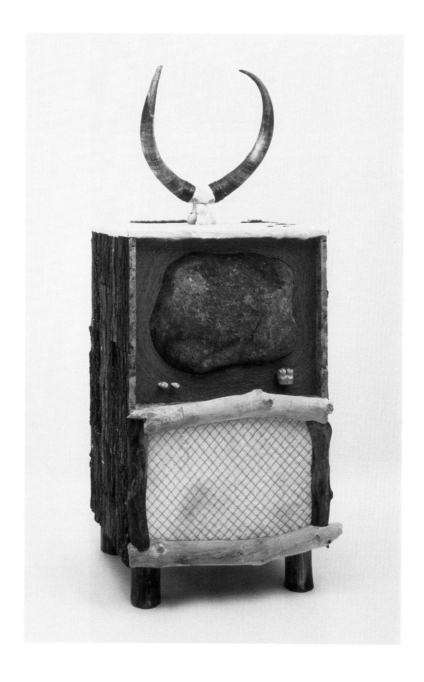

Artists' Biographies

Russell Baldon
Born 1964 in Chico, CA
Lives in San Francisco, CA

EDUCATION
1998 MFA, San Diego State University, San Diego, CA
1992 BFA, California College of Arts and Crafts, Oakland, CA

PROFESSIONAL POSITIONS

2001 Summer workshop instructor, Anderson Ranch Arts Center, Snowmass Village, CO
2001 Summer workshop instructor, Penland School of Crafts, Penland, NC
1999 Summer workshop instructor, Haystack School of Craft, Deer Isle, ME
1998– Founding partner of Pokensniff Studios, Alameda, CA
1996–97 Lecturer, San Diego State University, San Diego, CA

SELECTED EXHIBITIONS
2001 *Le Bain: Studio Furniture for the Bathroom*, Gallery NAGA, Boston, MA
2000 San Francisco Craft and Folk Art Museum, San Francisco, CA
1999 *California Craft*, Laguna Art Museum, Laguna Beach, CA
1999 *Design 2000*, Contract Design Center, San Francisco, CA
1998 *Furniture Redefined*, Oceanside Museum of Art, Oceanside, CA
1998 *Evolution in Form*, Arrowmont School of Arts and Crafts, Gatlinburg, TN
1998 *Studio Furniture*, The Society of Arts and Crafts, Boston, MA
1997 *Truth and Fiction*, Everett Gee Jackson Gallery, San Diego, CA
1997 *Mixed Result*, Flor y Canto Gallery, SDSU, San Diego, CA
1997 *Emerging Artists: Furniture and Wood*, The Society of Arts and Crafts, Boston, MA

Garry Knox Bennett
Born 1934 in Alameda, CA
Lives in Oakland, CA

EDUCATION
Attended California College of Arts and Crafts, Oakland, CA

PROFESSIONAL POSITIONS
1975– Independentl studio furniture maker

SELECTED EXHIBITIONS
2001 *Made in Oakland: The Furniture of Garry Knox Bennett*, American Craft Museum, New York, NY (solo)
2001 *Garry Knox Bennett Furniture*, Leo Kaplan Modern, New York, NY (solo)
2001 *Tablelamps*, Leo Kaplan Gallery, New York, NY
2001 *What's in a Name? New Jewelry by Garry Knox Bennett a.k.a. Gerralldo Bennuci*, Julie: Artisans' Gallery, New York, NY
 Mint Museum of Craft & Design, Charlotte, NC
 San Francisco Museum of Modern Art, San Francisco, CA
 Los Angeles Craft and Folk Art Museum, Los Angeles, CA
 Smithsonian American Art Museum's Renwick Gallery, Washington, DC
 Franklin Parrasch Gallery, New York, NY
1997 *100 Lamps*, Peter Joseph Gallery, New York, NY

SELECTED COLLECTIONS
American Craft Museum, New York, NY
Fine Arts Museums of San Francisco, San Francisco, CA
Museum of Fine Arts, Boston, MA
Oakland Museum of California, Oakland, CA
Smithsonian American Art Museum's Renwick Gallery, Washington, DC
San Francisco Museum of Modern Art, San Francisco, CA

AWARDS
1996 American Craft Council, College of Fellows
1984 National Endowment for the Arts, Merit Grant
1975 Contemporary Crafts of the Americas, award

Andy Buck

Born 1966 in Baltimore, MD
Lives in Rochester, NY

EDUCATION
1993 MFA, Rhode Island School of Design, Providence, RI
1987 BA, Virginia Commonwealth University, Richmond, VA

PROFESSIONAL POSITIONS
1999–2001 Visiting assistant professor, School for American Crafts, Rochester Institute of Technology, Rochester, NY
1997–99 Assistant professor, Oregon College of Art and Craft, Portland, OR
1995–97 Wood program director/ artist in residence, Peters Valley Craft Center, Layton, NJ

SELECTED EXHIBITIONS
2000 *2000 & Ten*, Pritam & Eames, East Hampton, NY
1999 *New Furniture*, John Elder Gallery, New York, NY (solo)
1999 *Transformations in Wood*, Society for Contemporary Craft, Pittsburgh, PA
1999 *Tools and Totems*, Snyderman Gallery, Philadelphia, PA (solo)
1999 *Drawn to Design*, Museum of Fine Arts, Boston, MA
1998 *Tools Rehandled*, John Elder Gallery, New York, NY (solo)
1997 *New England Furniture Makers*, Museum of Art, New Bedford, MA
1997 *Survey of North American Contemporary Furniture*, Neuberger Museum of Art, State University of New York, Purchase, NY
1996 *Circles & Stripes*, Clark Gallery, Lincoln, MA (solo)
1996 *Artists Choose Artists*, Peter Joseph Gallery, New York, NY

SELECTED COLLECTIONS
Bayly Art Museum of the University of Virginia, Charlottesville, VA
Marc and Diane Grainer
Peter Joseph Estate
Merck Corporation
Peters Valley Craft Center, Layton, NJ

AWARDS
1998 New Jersey Council on the Arts, Individual Artist Fellowship

John Cederquist

Born 1946 in Altadena, CA
Lives in Capistrano Beach, CA

EDUCATION
1971 MA, California State University at Long Beach
1969 BA, California State University at Long Beach

SELECTED EXHIBITIONS
2001 *Contemporary Art Furniture: Sam Maloof, John Cederquist, Wendy Maruyama*, Arizona State University Art Museum, Tempe, AZ
1997–99 *John Cederquist: Reality of Illusion*, Oakland Museum of California, Oakland, CA; Smithsonian American Art Museum's Renwick Gallery, Washington, DC
1997 *John Cederquist*, Franklin Parrasch Gallery, New York, NY (solo)
1993 *California Dreaming: Revisited*, Franklin Parrasch Gallery, New York, NY
1989 *New American Furniture*, Museum of Fine Arts, Boston, MA, multiple venues
1986 *The Eloquent Object*, Philbrook Museum of Art, Tulsa, OK, multiple venues
1985 *Craft Today: Poetry of the Physical*, American Craft Museum, New York, NY, multiple venues
1983 *Deceptions*, Los Angeles Craft and Folk Art Museum, Los Angeles, CA
1983 *Made in LA: Los Angeles Commemorates Two Hundred Years*, Los Angeles Craft and Folk Art Museum, Los Angeles, CA
1980 *California Woodworking*, Oakland Museum of California, Oakland, CA

AWARDS
1986 National Endowment for the Arts, award
1977 National Endowment for the Arts, award

James Michael Dietz

Born 1967 in Santa Barbara, CA
Lives in Madison, WI

EDUCATION
1996 MFA, University of Wisconsin–Madison
1990 BS, University of Puget Sound, Tacoma, WA

PROFESSIONAL POSITIONS
1996– J. M. Dietz Woodworking, Mt. Horeb, WI
1997–99 Lecturer, University of Wisconsin–Madison

SELECTED EXHIBITIONS
2001 *Philadelphia Furniture and Furnishings Show*, Pennsylvania Convention Center, Philadelphia, PA
2000 *Studio Furniture*, Wisconsin Academy Gallery, Madison, WI (solo)
2000 *Philadelphia Furniture and Furnishings Show*, Pennsylvania Convention Center, Philadelphia, PA
2000 *Art Furniture: The Hand that Forms*, The Annex Gremillion & Co., Houston, TX
1999 *Chair Show 3*, Blue Ridge Parkway's Folk Art Center, Asheville, NC; Piedmont Arts Association, Martinsville, VA; The Arkansas Art Center, Little Rock, AR
1999 *UW–Madison Department of Art Faculty Exhibition*, Elvehjem Museum of Art, Madison, WI
1999 *42nd Annual Beloit and Vicinity Exhibition*, Wright Museum of Art, Beloit, WI
1998 *Objects of Desire*, R. Peoples Jr. Gallery, Austin, TX
1998 *10th Annual International Contemporary Furniture Fair*, Jacob K. Javits Convention Center, New York, NY
1997 *Artful Furniture*, Evanston Art Center, Evanston, IL

AWARDS
1999 *42nd Annual Beloit and Vicinity Exhibition*, Best of Show
1998 Wisconsin Arts Board, travel grant

John Dunnigan

Born 1950 in Providence, RI
Lives in West Kingston, RI

EDUCATION
1980 MFA, Rhode Island School of Design, Providence, RI
1972 BA, University of Rhode Island, Kingston, RI

PROFESSIONAL POSITIONS
1975– John Dunnigan Studio, West Kingston, RI
1996– Professor, Rhode Island School of Design, Providence, RI
1980–96 Lecturer, Rhode Island School of Design, Providence, RI

SELECTED EXHIBITIONS
1999 *New Furniture*, The Butler Institute of American Art, Trumbull Branch, Howland, OH
1997 *Embracing Beauty: Aesthetic Perfection in Contemporary Art*, Huntsville Museum of Art, Huntsville, AL
1996 *John Dunnigan*, Peter Joseph Gallery, New York, NY (solo)
1994 *Contemporary Art in Rhode Island*, Museum of Art, Rhode Island School of Design, Providence, RI
1993 *John Dunnigan: New Works*, Peter Joseph Gallery, New York, NY (solo)
1992 *Please Be Seated*, Crafts Council Gallery, Dublin, Ireland
1991 *John Dunnigan*, Peter Joseph Gallery, New York, NY (solo)
1990 *The Art of John Dunnigan*, Pritam & Eames, East Hampton, NY (solo)
1989 *New American Furniture*, Museum of Fine Arts, Boston, MA, multiple venues
1986 *The Furniture of John Dunnigan*, Pritam & Eames, East Hampton, NY (solo)

SELECTED COLLECTIONS
Museum of Art, Rhode Island School of Design, Providence, RI
Museum of Fine Arts, Boston, MA
National Museum of American Art, Smithsonian Institution, Washington, DC

AWARDS
1994 Rhode Island Council on the Arts, Artist Fellowship Award for Design
1990 Rhode Island Council on the Arts, Artist Fellowship Award for Craft

Bradley P. Engstrom
Born 1955 in Oak Park, IL
Lives in Brooklyn, NY

EDUCATION
2000 MFA, University of Wisconsin–Madison
1996 BS, University of Wisconsin–Madison

PROFESSIONAL POSITIONS
Studio artist

SELECTED EXHIBITIONS
2001 Smithsonian Craft Show, Washington, DC
2001 Philadelphia Furniture Show, Philadelphia, PA
2000 *Benchmark at Workbench*, Workbench Furniture, Madison, WI
2000 *Colors*, 7th Floor Gallery, University of Wisconsin–Madison (solo)
1999 *Splinters*, Ahrnsbrak Gallery, University of Wisconsin-Marathon County, Wausau, WI
1998 *The 70th Annual Juried Student Art Show*, Wisconsin Union Porter Butts Gallery, Madison, WI
1998 International Contemporary Furniture Fair, New York, NY

AWARDS
2000 The Wisconsin Union Directorate Art Committee, Special Recognition Award

Christine M. Enos
Born 1970 in Syracuse, NY
Lives in Indianapolis, IN

EDUCATION
1998 MFA, San Diego State University, San Diego, CA
1992 BFA, State University of New York, Purchase, NY

PROFESSIONAL POSITIONS
1999– Assistant professor, Herron School of Art at Indiana University Purdue University at Indianapolis, Indianapolis, IN
1999 Adjunct faculty, Oregon College of Art and Craft, Portland, OR
1998 Adjunct faculty, San Diego State University, San Diego, CA

SELECTED EXHIBITIONS
2000 *enLIGHTened ART*, Alliance for the Arts, Fort Meyers, FL

2000 *Fairy Tales*, Woman Made Gallery, Chicago, IL
1999 *The Inquisitive Object*, Portland, OR
1999 *Furniture Redefined—San Diego's New Tradition*, Oceanside Museum of Art, Oceanside, CA
1998 *Holiday Box Show*, Ariana Gallery, Royal Oaks, MI
1998 *Studio Furniture, San Diego State University*, The Society of Arts and Crafts, Newbury Street Gallery, Boston, MA
1998 *DESCRY*, Simay Space Gallery, San Diego, CA
1998 *COLLABORATION*, Flor y Canto Gallery, SDSU, San Diego, CA
1997 *Back to School*, Visual Arts Gallery, SUNY Purchase
1997 *WALLWORKS*, Artcore/ Brewery Annex, LA Artcore, Los Angeles, CA

Brian Gladwell
Born 1947 in North Battleford, Saskatchewan, Canada
Lives in Regina, SK, Canada

EDUCATION
1970 University of Saskatchewan, Saskatoon, SK

PROFESSIONAL POSITIONS
1996– The Furniture Society, trustee
1983– Woodworker in residence, Neil Balkwill Civic Arts Centre, Regina, SK
1973– Independent furniture maker

SELECTED EXHIBITIONS
1999 *1979–1999*, Susan Whitney Gallery, Regina, SK
1997 *Survey of North American Contemporary Furniture*, Neuberger Museum of Art, State University of New York, Purchase, NY
1993 *Traditional Images/Contemporary Reflections*, Saskatchewan Craft Gallery, Saskatoon, SK
1993 *Brian Gladwell: Twelve Works*, Mendel Art Gallery, Saskatoon, SK (solo)
1992 *A Treasury of Canadian Craft*, Canadian Craft Museum, Vancouver, BC, multiple venues
1991 *Brian Gladwell*, Susan Whitney Gallery, Regina, SK (solo)
1990 *Brian Gladwell: Cardboard Furniture*, San Francisco Museum of Craft and Folk Art, CA
1988 *Brian Gladwell*, Susan Whitney Gallery, Regina, SK (solo)
1987 *Brian Gladwell: Furniture*, Dunlop Art Gallery, Regina, SK (solo)

SELECTED COLLECTIONS
Canadia Council Art Bank
M. Joan Chaimera and Barbra Amesbury, Toronto
City of Regina, SK
Dunlop Art Gallery, Regina, SK
MacKenzie Art Gallery, Regina, SK
Mendel Art Gallery, Saskatoon, SK
The Saskatchewan Arts Board Permanent Collection

AWARDS
1992 Saskatchewan Arts Board Individual Assistance
 "B" grant
1990 Saskatchewan Arts Board "B" grant
1989 Canada Council "B" grant; Saskatchewan Arts
 Board "B" grant
1986 Saskatchewan Arts Board "B" grant

Jenna Goldberg
Born 1968 in Brewster, NY
Lives in Asheville, NC

EDUCATION
1994 MFA, Rhode Island School of Design, Providence, RI
1990 BFA, The University of the Arts, Philadelphia, PA

PROFESSIONAL POSITIONS
 Studio artist
2000 Workshop instructor, Anderson Ranch Arts Center,
 Snowmass Village, CO
2000 Workshop instructor, Haystack Mountain School of
 Crafts, Deer Isle, ME
1998 Workshop instructor, Penland School of Crafts,
 Penland, NC

SELECTED EXHIBITIONS
2000 *Beginnings and Endings*, Asheville Museum of Art,
 Asheville, NC
2000 *Cups, Cupboards, and Cabinets*, Signature Gallery,
 Atlanta, GA
2000 *Studio Furniture: A Fine Art Invitational*, Memphis
 College of Art, Memphis, TN
2000 Clark Gallery, Lincoln, MA
1999 *The Circle Unbroken*, Appalachian Center for
 Crafts, Smithville, TN, multiple venues
1999 Fall Show, Pritam & Eames, East Hampton, NY
1999 *East of the Mississippi*, Bennett Gallery,
 Knoxville, TN
1999 Smithsonian Craft Show, Washington, DC
1998 Philadelphia Museum of Art Craft Show,
 Philadelphia, PA

1996 Jenna Goldberg, Gallery NAGA, Boston, MA (solo)

SELECTED COLLECTIONS
Collection of Judy Coady
Collection of Mignon Durham
Collection of Bill Joy and Sara Ransford
Collection of Seymour and Carol Levin
Collection of Sam and Alfreda Maloof

AWARDS
2000 North Carolina Arts Council grant

Patrick Hall
Born 1962 in Germany (Australian citizen)
Lives in North Hobart, Tasmania, Australia

EDUCATION
1986 BFA, University of Tasmania, Hobart, Australia

PROFESSIONAL POSITIONS
1999 Board Member of the Visual Arts/Crafts Fund,
 Australia Council
1994–95 Board Member of the Visual Arts & Design Panel,
 Arts Tasmania
1988 Partner in the design company PHISH Design
1985–91 Board of Directors at Designer-Makers Tasmania,
 Cooperative

SELECTED EXHIBITIONS
2000 *Soliloquy: Conversations with the Inanimate*,
 Handmark Gallery, Hobart, Tasmania (solo)
2000 *Against the Grain (Australian Sculptural Furni-
 ture)*, Brisbane City Gallery, Brisbane, Queensland
1999 TMAG Commissions, Tasmanian Museum & Art
 Gallery, Hobart, Tasmania
1998 *Places for the Safe & Misplaced*, Handmark
 Gallery, Hobart, Tasmania (solo)
1998 *Mapping Identity*, Object Gallery, Centre for
 Contemporary Craft, Sydney, New South Wales
1996 *McAvery's Amazing Ornithological Exhibits &
 Other Oddities*, Handmark Gallery, Hobart,
 Tasmania (solo)
1996–99 *Sculpture Objects Functional Art (SOFA)*,
 Navy Pier, Chicago, IL
1995 *National Craft Awards*, National Gallery of
 Victoria, Melbourne, Victoria
1993 *Tall Stories from the Art World*, Handmark Gallery,
 Hobart, Tasmania (solo)

continued on following page

1992 *Babel Towers and Other Constructions*, The Jam
 Factory Craft & Design Centre, Adelaide, South
 Australa (solo)

SELECTED COMMISSIONS
Private Collections in Australia, Europe, UK, USA
Powerhouse Museum, Sydney, Australia
Tasmanian Museum & Art Gallery, Hobart, Tasmania

Michael Hurwitz
Born 1955 in Miami, FL
Lives in Philadelphia, PA

EDUCATION
1979 BFA, Boston University, Boston, MA
1975 Massachusetts College of Art, Boston, MA

PROFESSIONAL POSITIONS
1980–2000 Workshop Instructor, Altos de Chavon,
 Dominican Republic; Workshop Instructor,
 Penland School, Penland, NC; Workshop Instructor,
 Appalachian Crafts Center, Smithville, TN
1989–90 Furniture design program head, The University
 of the Arts, Philadelphia, PA

SELECTED EXHIBITIONS
2001 Michael Hurwitz, Pritam & Eames,
 East Hampton, NY (solo)
1998 Michael Hurwitz, John Elder Gallery,
 New York, NY (solo)
1996 Michael Hurwitz, Peter Joseph Gallery,
 New York, NY (solo)
1994 Visiting Artist Exhibition, The Contemporary
 Museum, Honolulu, HI
1994 Michael Hurwitz, Peter Joseph Gallery,
 New York, NY (solo)
1992 Michael Hurwitz, Peter Joseph Gallery,
 New York, NY (solo)
1991 *Masterworks*, Peter Joseph Gallery, New York, NY
1990 *10 x 10*, Anniversary Show, Pritam & Eames,
 East Hampton, NY
1989 Michael Hurwitz, Pritam & Eames,
 East Hampton, NY (solo)
1989 *New American Furniture*, Museum of Fine Arts,
 Boston, MA, multiple venues

SELECTED COLLECTIONS
Museum of Art, Rhode Island School of Design,
Providence, RI

Museum of Fine Arts, Boston, MA
Smithsonian American Art Museum's Renwick Gallery,
Washington, DC
Yale University Art Gallery, New Haven, CT

AWARDS
1999 PEN Fellowship
1997 Japan Foundation, Japan Fellowship
1992 National Endowment for the Arts, Visual Arts
 Fellowship
1990 National Endowment for the Arts, Visual Arts
 Fellowship
1989 US-Japan Friendship Commission Fellowship
1988 National Endowment for the Arts Visual Arts
 Fellowship,
1986 Pennsylvania Council on the Arts, Crafts
 Fellowship
1985 Altos de Chavon, Dominican Republic,
 Artist-in-Residence Fellowship

C. R. "Skip" Johnson
Born 1928 in Painted Post, NY
Lives in Stoughton, WI

EDUCATION
1960 MFA, School for American Craftsman,
 Rochester, NY
1957 BS, State University of New York, Oswego, NY

PROFESSIONAL POSITIONS
1990– Professor emeritus of art, University of Wisconsin–
 Madison
1965–90 Professor of art, University of Wisconsin–Madison
1963 Summer workshop instructor Penland School of
 Crafts, Penland, NC
1961 Summer Workshop Instructor, Haystack School of
 Craft, Deer Isle, ME

SELECTED EXHIBITIONS
1997–2001 *Bats and Bowls*, Kentucky Art and Craft
 Gallery, Louisville, KY, multiple venues
1994 *National Woodturning Exhibition*, Nunawading
 Art Center, Victoria, Australia
1988 *International Turned Objects*, Port of History
 Museum, Philadelphia, PA
1980 *Iron and Wood*, Louisville Gallery, Louisville, KY
1967 *Fun and Fantasy*, Signature Gallery, Atlanta, GA
1961 Munson-Williams-Proctor Museum, Utica, NY

SELECTED COLLECTIONS
Arrowmont School of Arts and Crafts, Gatlinburg, TN
The Wood Turning Center, Philadelphia, PA

AWARDS
1974 National Endowment for the Arts, grant for craft
1970 National Endowment for the Arts, sponsorship at
 Penland School of Crafts

Kimberly Kelzer
Born 1957 in El Paso, TX
Lives in Freeland, WA

EDUCATION
1990 MFA, Southeastern Massachusetts University,
 North Dartmouth, MA
1987 BA, San Jose State University, San Jose, CA

PROFESSIONAL POSITIONS
1999 Summer workshop instructor, Arrowmont School
 of Arts and Crafts, Gatlinburg, TN
1999 Summer workshop instructor, Anderson Ranch
 Arts Center, Snowmass Village, CO
1998 Summer workshop instructor, Peters Valley Craft
 Center, Layton, NJ
1997 Summer instructor, Oregon College of Art and
 Craft, Portland, OR

SELECTED EXHIBITIONS
2001 Kimberly Kelzer, John Elder Gallery, New York,
 NY (solo)
2001 Le Bain: Studio Furniture for the Bathroom,
 Gallery NAGA, Boston, MA
2001 Stools, Tecera Gallery, Palo Alto, CA
2001 Turned Multiples, The Wood Turning Center,
 Philadelphia, PA
2001 Anything with a Drawer, Galleria Mesa, Mesa, AZ
2000 Little Bowl Show, Saskatchewan Craft Council,
 Saskatoon, SK, Canada
1998 Kimberly Kelzer, Museo, Langley, WA (solo)
1997 Survey of North American Contemporary Furni-
 ture, Neuberger Museum of Art, State University of
 New York, Purchase, NY
1997 The Boston International Fine Art Show, Park
 Plaza Castle, Boston, MA
1996 Accents on Design: Contemporary Art Furniture,
 Amarillo Museum of Art, Amarillo, TX

SELECTED COLLECTIONS
Robert Bergman
Children's Museum in Dartmouth, South Dartmouth, MA
Anne Gould Hauberg
Nancy Nordhoff

AWARDS
1993 National Endowment for the Arts Regional
 Fellowship for Visual Arts

Silas Kopf
Born 1949 in Warren, PA
Lives in Northampton, MA

EDUCATION
1989 École Boulle, Paris, France
1974–76 Apprentice to Wendell Castle
1972 AB, Princeton University, Princeton, NJ

SELECTED EXHIBITIONS
2001 Silas Kopf, Gallery Henoch, New York, NY (solo)
1995 Silas Kopf, Gallery Henoch, New York, NY (solo)
1993 Conservation by Design, Museum of Art, Rhode
 Island School of Design, Providence, RI
1992 Silas Kopf, Gallery Henoch, New York, NY (solo)
1990–93 Art That Works: Decorative Arts of the 80's, Mint
 Museum of Art, Charlotte NC, 12 US venues

SELECTED COLLECTIONS
American Craft Museum, New York, NY
Smith College Museum of Art, Northampton, MA
Yale University Art Gallery, New Haven, CT

AWARDS
1997 Boston Society of Arts and Crafts Award
1996 New England Crafts Foundation
1988 National Endowment for the Arts, craftsman
 fellowship

Thomas Loeser
Born 1956 in Boston, MA
Lives in Madison, WI

EDUCATION
1992 MFA, University of Massachusetts, North
 Dartmouth, MA
1983 BFA, Boston University, Boston, MA
1979 BA, Haverford College, Haverford, PA

continued on following page

PROFESSIONAL POSITIONS

1992– Professor of art, University of Wisconsin–Madison
1989–90 Adjunct professor, California College of Arts and Crafts, Oakland, CA
1987–88 Instructor, Rhode Island School of Design, Providence, RI

SELECTED EXHIBITIONS

2001 *Rollers, Spinners, and Sliders*, Leo Kaplan Modern, New York, NY
1999 *Please Be Seated*, Yale University Art Gallery, New Haven, CT
1996 *This Ain't No Floor Show*, Peter Joseph Gallery, New York, NY (solo)
1995 *Additions, Distractions, Multiple Complications and Divisions*, Peter Joseph Gallery, New York, NY (solo)
1992 *Sixty-five Drawers, Eleven Doors and Four Lids*, Peter Joseph Gallery, New York, NY (solo)
1990–93 *Art That Works: Decorative Arts of the 80's*, Mint Museum of Art, Charlotte NC, 12 US venues
1990 *Ten Years of Collecting*, Museum of Art, Rhode Island School of Design, Providence, RI
1989–93 *Craft Today USA*, Musée des Arts Décoratifs, Paris, France, 14 European venues
1987 *Grand Prix des Metiers d'Art: New York/Montreal*, Hall d'Exposition des Archives National, Montreal and Quebec
1984 *Postmodern Colour, New Furniture*, Victoria and Albert Museum, London

SELECTED COLLECTIONS

American Craft Museum, New York, NY
The Brooklyn Museum, Brooklyn, NY
Cooper-Hewitt National Design Museum, Smithsonian Institution, New York, NY
Elvehjem Museum of Art, University of Wisconsin–Madison, Madison, WI
Milwaukee Art Museum, Milwaukee, WI
Museum of Art, Rhode Island School of Design, Providence, RI
The Museum of Fine Arts, Houston, TX
Smithsonian American Art Museum's Renwick Gallery, Washington, DC
Yale University Art Gallery, New Haven, CT

AWARDS

1994 National Endowment for the Arts, Visual Artist Fellowship
1992 National Endowment for the Arts, Creative Arts Exchange Fellowship to Japan
1990 National Endowment for the Arts, Visual Artist Fellowship
1988 National Endowment for the Arts, Visual Artist Fellowship
1984 National Endowment for the Arts, Visual Artist Fellowship
1984 Massachusetts Council on the Arts and Humanities, Artist Fellowship

Kristina Madsen

Born 1955 in Northampton, MA
Lives in Southampton, MA

EDUCATION

1974–79 Leeds Design Workshops, Easthampton, MA

PROFESSIONAL POSITIONS

1988 Artist in Residence, School of Art, University of Tasmania, Hobart, Tasmania, Australia
1979–84 Instructor, Leeds Design Workshops, Easthampton, MA

SELECTED EXHIBITIONS

1999 Pritam & Eames, East Hampton, NY
1997 *Survey of North American Contemporary Furniture*, Neuberger Museum of Art, State University New York, Purchase, NY
1995 Pritam & Eames, East Hampton, NY
1993 *Conservation by Design*, Museum of Art, Rhode Island School of Design, Providence, RI
1993 Pritam & Eames, East Hampton, NY
1991 Pritam & Eames, East Hampton, NY
1989 *New American Furniture*, Museum of Fine Arts, Boston, MA, multiple venues
1982 *Women Are Woodworking*, The Gallery at Workbench, New York, NY

SELECTED COLLECTIONS

Brockton Art Museum, Brockton, NY
Museum of Art, Rhode Island School of Design, Providence, RI
Museum of Fine Arts, Boston, MA
National Museum of American Art, Smithsonian Institution, Washington, DC
North Carolina State University Gallery of Art and Design, Raleigh, NC
Yale University Art Gallery, New Haven, CT

AWARDS

1997 New England Foundation for the Arts, Regional
 Fellowship for Visual Arts
1991 Fulbright Grant to study in Fiji
1981 National Endowment for the Arts, Craftsman
 Fellowship

Wendy Maruyama

Born 1952 in La Junta, CO
Lives in San Diego, CA

EDUCATION

1980 MFA, Rochester Institute of Technology,
 Rochester, NY
1975 BFA, San Diego State University, San Diego, CA
1976–78 Boston University, Boston, MA

PROFESSIONAL POSITIONS

1989– Program head, San Diego State University,
 San Diego, CA
1985–98 Program head, California College of Arts and
 Crafts, Oakland, CA
1980–85 Program head, Appalachian Center for Crafts,
 Tennessee Technological University, Smithville, TN

SELECTED EXHIBITIONS

2001 *Contemporary Art Furniture: Sam Maloof, John
 Cederquist, Wendy Maruyama*, Arizona State
 University Art Museum, Tempe, AZ
1999 *Wendy Maruyama*, John Elder Gallery, New York,
 NY (solo)
1997 *Hako*, NUNO Inc., multiple venues in Japan (solo)
1997 *Centennial Furniture Exhibition*, The Society of
 Arts and Crafts, Boston, MA
1996 *Points of Light*, Menorah exhibition, Margolis
 Gallery, Houston, TX
1996 *World Urushi Culture Council Exhibition*, Fujita
 Corporation, Tokyo, Japan
1995 *Wendy Maruyama: Simple Pleasures and Indul-
 gences*, Peter Joseph Gallery, New York, NY
1995 *Breaking Barriers: Recent American Craft*,
 American Craft Museum, New York, NY, multiple
 venues
1994 *Functional Sculpture*, Indigo Gallery, Boca Raton, FL
1993 *Conservation by Design*, Museum of Art, Rhode
 Island School of Design, Providence, RI

SELECTED COLLECTIONS

American Craft Museum, New York, NY
Mint Museum of Art, Charlotte, NC
Oakland Museum of California, Oakland, CA
Arizona State University Art Museum, Tempe, AZ

AWARDS

1995 National Endowment for the Arts,
 Japan Fellowship
1994 Fulbright Grant, Lecture and Research Residency
 in England
1992 National Endowment for the Arts, Artist in
 Residency Fellowship, France
1990 National Endowment for the Arts, Visual Artist
 Fellowship

Alphonse Mattia

Born 1947 in Philadelphia, PA
Lives in Westport, MA

EDUCATION

1973 MFA, Rhode Island School of Design,
 Providence, RI
1969 BFA, Philadelphia College of Art, Philadelphia, PA

PROFESSIONAL POSITIONS

1990– Adjunct professor, Rhode Island School of Design,
 Providence, RI
1988–91 Associate professor and program head, Southeast-
 ern Massachusetts University, Dartmouth, MA
1985–88 Professor and program head, Swain School of
 Design, New Bedford, MA

SELECTED EXHIBITIONS

2001 *20th Anniversary Exhibition*, Pritam & Eames,
 East Hampton, NY
1999 *The Art of Craft: Contemporary Works from the
 Saxe Collection*, Fine Arts Museums of San
 Francisco, San Francisco, CA
1999 Permanent Collection Selections, Smithsonian
 American Art Museum's Renwick Gallery, Wash-
 ington, DC
1997 *Embracing Beauty: Aesthetic Perfection in
 Contemporary Art*, Huntsville Museum of Art,
 Huntsville, AL
1997 *Survey of North American Contemporary Furni-
 ture*, Neuberger Museum of Art, State University
 New York, Purchase, NY
1995 *Alphonse Mattia: Points of Reference*, Peter Joseph
 Gallery, New York, NY
1993 *Bookshelves Any Size*, Peter Joseph Gallery, New
 York, NY

continued on following page

1989 *New American Furniture*, Museum of Fine Arts, Boston, MA, multiple venues

1987 *The Eloquent Object*, Philbrook Museum of Art, Tulsa, OK, multiple venues

SELECTED COLLECTIONS
American Craft Museum, New York, NY
Museum of Art, Rhode Island School of Design, Providence, RI
Museum of Fine Arts, Boston, MA
Nations Bank, Atlanta, GA
Philip Morris Company, New York, NY
Yale University Art Gallery, New Haven, CT

AWARDS
1986 Massachusetts Artists Foundation, Fellowship in Crafts

1984 National Endowment for the Arts, Visual Artists Fellowship Grant

Judy Kensley McKie
Born 1944 in Boston, MA
Lives in Cambridge, MA

EDUCATION
1966 BFA, Rhode Island School of Design, Providence, RI

SELECTED EXHIBITIONS
2000 Pritam & Eames, East Hampton, NY (solo)

2000 *Defining Craft*, American Craft Museum, New York, NY

2000 *Visual Memoirs*, Rose Art Museum, Brandeis University, Waltham, MA

1999 *Please Be Seated*, Yale University Art Gallery, New Haven, CT

1999 *Drawn to Design*, Museum of Fine Arts, Boston, MA

1995 Judy Kensley McKie, Gallery NAGA, Boston, MA (solo)

1993 Judy Kensley McKie, Albuquerque Museum, Albuquerque, NM (solo)

1989 *New American Furniture*, Museum of Fine Arts, Boston, MA, multiple venues

1987 Judy Kensley McKie, Eve Mannes Gallery, Atlanta, GA (solo)

1986 *Design in America*, United States Information Agency, Washington, DC, multiple venues

SELECTED COLLECTIONS
Addison Gallery of American Art, Andover, MA
American Craft Museum, New York, NY
ARC Union, Paris, France
De Cordova Museum and Sculpture Park, Lincoln, MA
Fine Arts Museums of San Francisco, San Francisco, CA
Frederick R. Weisman Art Foundation, Los Angeles, CA
Museum of Fine Arts, Boston, MA
Philadelphia Museum of Art, Philadelphia, PA
Smithsonian American Art Museum's Renwick Gallery, Washington, DC
Yale University Art Gallery, New Haven, CT

AWARDS
1998 American Craft Council, College of Fellows

1989 Louis Comfort Tiffany Foundation Award

1982 National Endowment for the Arts, Craftsman Fellowship

1980 Massachusetts Artists Foundation Fellowship

1979 National Endowment for the Arts, Craftsman Fellowship

1966 Rhode Island School of Design European Honors Program, Rome

Jere Osgood
Born 1936 in Staten Island, NY
Lives in Wilton, NH

EDUCATION
1961 Scandinavian Seminar, Denmark

1960 BFA, School for American Craftsmen, Rochester Institute of Technology, Rochester, NY

PROFESSIONAL POSITIONS
1975–85 Faculty Program in Artisanry, Boston University, Boston, MA

1972–75 Faculty, School for American Craftsmen, Rochester Institute of Technology, Rochester, NY

1957– Studio craftsman

SELECTED EXHIBITIONS
2000 *The Art of Craft*, Hood Museum of Art, Dartmouth College, Hanover, NH

2000 New Hampshire Furniture Masters Association Auctions and Exhibitions, Concord, NH

1999 *New Furniture: Jere Osgood & Thomas Hucker*, Pritam & Eames, East Hampton, NY

1992 *American Crafts*, Smithsonian American Art Museum's Renwick Gallery, Washington, DC

1989 *New American Furniture*, Museum of Fine Arts, Boston, MA, multiple venues
1989–93 *Craft Today USA*, Musée des Arts Décoratifs, Paris, France, traveled to 14 European countries
1986 *Craft Today: Poetry of the Physical*, American Craft Museum, New York, NY
1969 *Objects USA*, Johnson Collection, Washington, DC
1967 Acquisitions Show, Museum of Contemporary Crafts, New York, NY
1962 *Young Americans*, Museum of Contemporary Crafts, New York, NY

SELECTED COLLECTIONS
American Craft Museum, New York, NY
The Currier Gallery of Art, Manchester, NH
Johnson Collection, Washington, DC
Museum of Art, Rhode Island School of Design, Providence, RI
Museum of Fine Arts, Boston, MA
New Hampshire Historical Society, Concord, NH
Smithsonian American Art Museum's Renwick Gallery, Washington, DC

AWARDS
1993 American Craft Council, College of Fellows
1988 National Endowment for the Arts, grant
1980 National Endowment for the Arts, grant

Emi Ozawa
Born 1962 in Tokyo, Japan
Lives in New Bedford, MA

EDUCATION
1992 MFA, Rhode Island School of Design, Providence, RI
1989 BFA, The University of the Arts, Philadelphia, PA
1982 AA, Joshibi University of Art and Design, Tokyo, Japan

PROFESSIONAL POSITIONS
1993–98 Designer, fabricator, mallet design
1992–94 Studio assistant to Somerson and Mattia, Westport, MA
1983–84 Designer, illustrator, YAP Corporation, Tokyo, Japan

SELECTED EXHIBITIONS
2001 *Celebrating Boxes*, Tullie House Museum and Art Gallery, Carlisle, UK

2000 *JOSHIBI: A Centenary Exhibition*, Gallery Mitsukoshi, Nihonbashi, Tokyo, Japan
2000 Invitational Box Exhibition, Del Mano Gallery, Pasadena, CA
2000 *Studio Furniture: A Fine Art Invitational*, Memphis College of Art, Memphis, TN
1999 *Boxes and Sculpture*, The Sarah Doyle Gallery, Providence, RI (solo)
1998 *Toys and Gadgets*, The Society of Arts and Crafts, Boston, MA
1997 *Contemprary North American Furniture*, Neuberger Museum of Art, State University of New York, Purchase, NY
1996 The White House Christmas Tree Ornaments, *Nutcracker*, Washington, DC
1996 *The Domestic Object: Articles for Everyday Living*, The Berkshire Museum, Pittsfield, MA; Worcester Center for Crafts, Worcester, MA; Fuller Museum of Art, Brockton, MA
1995 *Please Be Seated: Master of Art of Seating*, Henry Morrison Flagler Museum, Palm Beach, FL

AWARDS
1999 American Craft Council Market, Baltimore, MD, honorable mention
1991 The Arkansas Arts Center Decorative Arts Museum, Little Rock AR, purchase award

Gordon Peteran
Born 1956 in Toronto, ON, Canada
Lives in Toronto, ON Canada

EDUCATION
1979 Ontario College of Art and Design, Toronto, ON

PROFESSIONAL POSITIONS
2001 Self-employed studio artist
1988–2001 Faculty, Ontario College of Art and Design, Toronto, ON
1994–2000 Faculty, Sherican College School of Art & Design, Oakville, ON
2000 Visiting artist, Anderson Ranch Arts Center, Snowmass Village, CO
2000 Instructor, Haystack School of Craft, Deer Isle, ME
1999 Visiting professor, Rhode Island School of Design, Providence, RI

SELECTED EXHIBITIONS
2000 *Blurred Boundaries*, Capitol Region Arts Center, Troy, NY

continued on following page

2000 *Comfort*, York Quay Gallery, Harbourfront, Toronto, ON

2000 *Canadian Furniture Exhibition*, Manitoba, MB

1998 *Curator's Focus*, Berman Museum of Art, Ursinus College, Collegeville, PA

1997 *Contemprary North American Furniture*, Neuberger Museum of Art, State University of New York, Purchase, NY

1992 *A Treasury of Canadian Craft*, Canadian Craft Museum, Vancouver, BC

1991 *Art Furniture*, Levison Kane Gallery, Boston, MA

SELECTED COLLECTIONS
Baycrest Center
Canadian Craft Museum, Vancouver, BC
Chalmers Family Foundation
Glenn Gould Foundation
Government of Ontario Art Collection
Labatt Brewery Art Collection

AWARDS
2000 Canada Council of the Arts, travel grant
1999 Ontario Arts Council, grant
1997 Canada Council of the Arts, grant
1995 Toronto Arts Awards, Protégé Award

Charles Radtke
Born 1964 in Hermann, MO
Lives in Cedarburg, WI

EDUCATION
1986 BS, Lombard Institute of Technology, Lombard, IL
1982–83 Southern Missouri State University, Joplin, MO

PROFESSIONAL POSITIONS
1989– Studio artist
1983–86 Furniture maker, St. Paschal Friary

SELECTED EXHIBITIONS
1996 *An Unfolding Process*, Plymouth Art Foundation, Plymouth, WI (solo)

1996 *Enhancing the Living Space*, West Bend Art Museum, West Bend, WI

1993 *Crafting Currents*, Lockport Gallery, Lockport, IL

1993 *Fine Furniture by Kyle Kirser and Charley Radtke*, Craft Alliance, St. Louis, MO

1989 *Contemporary Religious Works*, 1989 Art Exposition, Columbus, OH

SELECTED COLLECTIONS
Roger Ford
Brent Kington
Smithsonian American Art Museum's Renwick Gallery, Washington, DC
University of St. Mary of the Lake Theological Chapel, Mundelein, IL

Jim Rose
Born 1966 in Beach Grove, IN
Lives in Kolberg, WI

EDUCATION
1988 BFA, School of the Art Institute of Chicago, Chicago, IL
1984–85 Bard College, Annandale-on-Hudson, NY

PROFESSIONAL POSITIONS
Studio artist

SELECTED EXHIBITIONS
2001 *Anything with a Drawer*, Mesa Arts Center, Mesa, AZ

2001 *23rd Annual Contemporary Crafts*, Mesa Arts Center, Mesa AZ

2000 *SOFA Chicago*, Ann Nathan Gallery, Chicago, IL

2000 *New Talent in Craft*, Charles A. Wustum Museum of Fine Arts, Racine, WI

2000 *Wisconsin Designer Craft Council Annual Exhibit*, Guenzel Gallery at the Peninsula Art School, Fish Creek, WI

2000 *Shaker in Steel: New Work*, Ann Nathan Gallery, Chicago, IL (solo)

2000 *Shaker Interpretations in Steel*, Edgewood Orchard Gallery, Fish Creek, WI (solo)

SELECTED COLLECTIONS
Smithsonian American Art Museum's Renwick Gallery, Washington, DC
Charles A. Wustum Museum of Fine Arts, Racine, WI

Mitch Ryerson
Born 1955 in Boston, MA
Lives in Cambridge, MA

EDUCATION
1982 BAA, Boston University Program in Artisanry

PROFESSIONAL POSITIONS
Studio artist

SELECTED EXHIBITIONS
2000 *Mitch Ryerson: New Work*, John Elder Gallery,
 New York, NY (solo)
2000 *Contemporary Studio Furniture*, Art Complex
 Museum, Duxbury, MA
2000 *Sculpture for the Outdoors*, Clark Gallery,
 Lincoln, MA
1997 *Mitch Ryerson: New Work*, Sybaris Gallery,
 Royal Oak, MI (solo)
1993 *Conservation by Design*, Museum of Art, Rhode
 Island School of Design, Providence, RI
1990–93 *Art That Works: Decorative Arts of the 80's*, Mint
 Museum of Art, Charlotte NC, 12 US venues
1989 *Contemporary Expressions*, Lyman Allyn Museum
 of Art at Connecticut College, New London, CT
1988 *Crafts Today: Poetry of the Physical*, American
 Craft Museum, New York, NY
1985 *Material Evidence*, Smithsonian American Art
 Museum's Renwick Gallery, Washington, DC
1984 *New Furniture*, Victoria and Albert Museum,
 London, England

SELECTED COLLECTIONS
Babson College, Wellesley, MA
Boston Public Library, Boston, MA
Cambridge Public Library. Cambridge, MA
City of Cambridge, MA
Peter Joseph Collection, New York, NY
Maude Morgan Visual Arts Center, Cambridge, MA
Museum of Fine Arts, Boston, MA

AWARDS
1998 The Society of Arts and Crafts, Boston, MA, Artist
 Award
1996 Philadelphia Furniture Show, Philadelphia, PA,
 Travel Award
1988 National Endowment for the Arts, Fellowship

Randy Shull
Born 1962 in Sandwich, IL
Lives in Asheville, NC

EDUCATION
1986 BFA, Rochester Institute of Technology,
 Rochester, NY

PROFESSIONAL POSITIONS
 Studio artist
1996 Adjunct professor, California College of Arts and
 Crafts, Oakland, CA
1987–91 Artist in residence, Penland School of Crafts,
 Penland, NC

SELECTED EXHIBITIONS
2001 Solo show, Snyderman Gallery, Philadelphia, PA
2000 Solo show, Tercera Gallery, San Francisco, CA
2000 Solo show, Hodges Tayler Gallery, Charlotte, NC
1998 Solo show, John Elder Gallery, New York, NY
1997 Solo Show, Mint Museum of Art, Charlotte, NC
1995 Solo show, Franklin Parrasch Gallery,
 New York, NY
1994 Solo show, Franklin Parrasch Gallery,
 New York, NY
1992 Solo show, North Carolina State University Gallery
 of Art & Design, Raleigh, NC

SELECTED COLLECTIONS
American Craft Museum, New York, NY
Asheville Art Museum, Asheville, NC
The Brooklyn Museum, Brooklyn, NY
High Museum of Art, Atlanta, GA
Mint Museum of Craft & Design, Charlotte, NC
Smithsonian American Art Museum's Renwick Gallery,
Washington, DC
The Speed Art Museum, Louisville, KY

AWARDS
1994 North Carolina Arts Council Fellowship Grant
1993 National Endowment for the Arts, Southern Arts
 Federation Grant
 Connamar Foundation Grant

Tommy Simpson
Born 1939 in Elgin, IL
Lives in Washington, CT

EDUCATION
1964 MFA, Cranbrook Academy of Art,
 Bloomfield Hills, MI
 BS, Northern Illinois University, DeKalb, IL

PROFESSIONAL POSITIONS
1979–80 Faculty, Rhode Island School of Design,
 Providence, RI

continued on following page

SELECTED EXHIBITIONS

2000 *Garden of the Heart*, American Craft Museum, New York, NY

1996 Tommy Simpson, Leo Kaplan Modern, New York, NY (solo)

1996 *Connecticut Artists Collection*, Lyman Allyn Museum of Art at Connecticut College, New London, CT

1995 *Breaking Barriers, Recent American Craft*, American Craft Museum, New York, NY, multiple venues

1994 *Tales and Traditions*, Craft Alliance, St. Louis, MO

1993 Tommy Simpson, Society for Contemporary Craft, Pittsburgh, PA (solo)

1993 *Functional Sculpture*, Indigo Gallery, Boca Raton, FL

1989 *New American Furniture*, Museum of Fine Arts, Boston, multiple venues

1987 *The Eloquent Object*, Philbrook Museum of Art, Tulsa, OK, multiple venues

1982 Tommy Simpson, American Craft Museum, New York, NY (solo)

SELECTED COLLECTIONS

American Craft Museum, New York, NY

Smithsonian American Art Museum's Renwick Gallery, Washington, DC

Wadsworth Atheneum, Hartford, CT

AWARDS

American Craft Council College of Fellows

1994 Society of Connecticut Crafts, Master Craftsman Award

1978 National Endowment for the Arts, Fellowship

Rosanne Somerson

Born 1954 in Philadelphia, PA

Lives in Westport, MA

EDUCATION

1976 BFA, Rhode Island School of Design, Providence, RI

PROFESSIONAL POSITIONS

1985– Faculty, Rhode Island School of Design, Providence, RI

1979– Owner, furniture designer and builder, Rosanne Somerson Furniture

1977–78 Teaching Fellow, Harvard University Center for Continuing Education

SELECTED EXHIBITIONS

2001 *Women Designers in the USA, 1900–2000: Diversity and Difference*, Bard Graduate Center for Studies in the Decorative Arts, New York, NY

2000 *Women in Furniture*, Leo Kaplan Modern, New York, NY

1999 *Furniture: Recent Works by RISD Faculty*, Butler Institute of American Art, Howland, OH

1999 *Permanent Collection Selections*, Smithsonian American Art Museum's Renwick Gallery, Washington, DC

1998 Ambassador's Residence, Art in Embassies Program, Tashkent, Uzbekistan

1997 *Embracing Beauty: Aesthetic Perfection in Contemporary Art*, Huntsville Museum of Art, Huntsville, AL

1995 *Rosanne Somerson, Points of View*, Peter Joseph Gallery, New York, NY (solo)

1993 *Rosanne Somerson: Earthly Delights*, Peter Joseph Gallery, New York, NY (solo)

1989–92 *Craft Today—USA*, Musée des Arts Décoratifs, Paris, France, 14 European venues

1989 *New American Furniture*, Museum of Fine Arts, Boston, MA, multiple venues

SELECTED COLLECTIONS

Anne and Ronald D. Abramson, Rockville, MD

Fuller Museum of Art, Brockton, MA

Huntsville Museum of Art, Huntsville, AL

Kohn, Penderson, Fox & Conway, New York, NY

Museum of Fine Arts, Boston, MA

Rhode Island School of Design, Providence, RI

Smithsonian American Art Museum's Renwick Gallery, Washington, DC

William and Ann Ziff, Pawling, NY

Yale University Art Gallery, New Haven, CT

AWARDS

1988 National Endowment for the Arts, Visual Artist Fellowship

1987 American Craft Awards Competition, The Guild, Grand Prize

1984 National Endowment for the Arts, Visual Artist Fellowship

1984 Fund for the Arts, WBZ Arts Grant

1984 Massachusetts Council on Arts and Humanities to Brockton Art Museum, New Works Grant

1983 Women in Design International Competition, Award of Outstanding Achievement

Charles Swanson

Born 1953 in Lorain, OH
Lives in South Dartmouth, MA

EDUCATION
1989 MFA, Rhode Island School of Design, Providence, RI
1975 BBA, Kent State University, Kent, OH

PROFESSIONAL POSITIONS
 Studio Artist
1989–97 Instructor, Rhode Island School of Design, Providence, RI

SELECTED EXHIBITIONS
1999 *Furniture: Recent Works by RISD Faculty*, Butler Institute of American Art, Howland, OH
1997 *Survey of North American Contemporary Furniture*, Neuberger Museum of Art, State University New York, Purchase, NY
1995 *Charles Swanson: New Furniture*, Snyderman Gallery, Philadelphia, PA (solo)
1994 Faculty Biennial, Museum of Art, Rhode Island School of Design, Providence, RI

AWARDS
1994 National Endowment for the Arts, Fellowship
1993 New England Foundation for the Arts, Fellowship

J. M. Syron

Born 1960 in Ohio
Lives in Massachusetts

EDUCATION
1977–82 Westchester Community College, Westchester County, NY
1977–81 Apprentice musical instrument maker with Steven Silverstein, New York, NY

PROFESSIONAL POSITION
1986– Furniture artist, designer, craftsman

Bonnie Bishoff

Born 1963 in Bryn Mawr, PA
Lives in Massachusetts

EDUCATION
1985 BA, Oberlin College, Oberlin, OH

PROFESSIONAL POSITIONS
1991– Furniture artist, polymer clay artist
1987–94 Middle school science teacher

SELECTED EXHIBITIONS for Syron & Bishoff
1999 *Polymer Clay*, The Society of Arts and Crafts, Boston, MA
1999 Annual Lighting Show, Del Mano Gallery, Pasadena, CA
1999 *Pull Up a Chair*, Meredith Gallery, Baltimore, MD
1998 *Overview in Polymer Clay*, Target Gallery, Alexandria, VA
1998 Annual Lighting Show, Del Mano Gallery, Pasadena, CA
1996 *Collaborative Forms*, Meridith Gallery, Baltimore, MD (duo show)
1996 *Pull Up a Chair*, Meredith Gallery, Baltimore, MD
1995 *Furniture: Details in Color*, The Society of Arts and Crafts, Boston, MA
1995 *The Chair Show*, Southern Highland Crafts Guild, Asheville, NC
1995 *Please Be Seated*, Henry Morrison Flagler Museum, Palm Beach, FL

SELECTED COLLECTIONS
Jill and Robert Ammerman
Bill and Andrea Hollis
Edward Johnson
Judith Lippman
Herta and Hans Loeser
Larry and Barbara Magid

AWARDS
1996 Niche Award, one-of-kind wood
1997 Fine Furnishings Providence, first prize, best company presentation

Bob Trotman

Born 1947 in Winston-Salem, NC
Lives in Casar, NC

EDUCATION
1988 Francisco Rivera, The Sculpture Center, New York, NY
1986 Robert Morris, The Atlantic Center for the Arts, New Smyrna Beach, FL
1985 James Suris, The Atlantic Center for the Arts, New Smyrna Beach, FL

continued on following page

1977 Sam Maloof, Penland School of Crafts, Penland, NC
1976 Jon Brooks, Penland School of Crafts, Penland NC
1969 BA, Washington and Lee University, Lexington, VA

SELECTED EXHIBITIONS
2001 *After the Fall*, Weatherspoon Art Gallery, University of North Carolina at Greensboro, Greensboro, NC (solo)
2001 *After the Fall*, Franklin Parrasch Gallery, New York, NY (solo)
2000 Recent Work, Hodges Taylor Gallery, Charlotte, NC (solo)
1998 *Residual Value*, Tryon Center for Visual Art, Charlotte, NC
1995–96 *ArtCurrents 20: Bob Trotman*, Mint Museum of Art, Charlotte, NC (solo)
1994 *Bob Trotman: A Retrospective of Furniture and Sculpture*, Visual Arts Program, North Carolina State University, Raleigh, NC
1992 Sculpture, Nexus Contemporary Art Center, Atlanta, GA (solo)
1990–93 *Art That Works: Decorative Arts of the 80's*, Mint Museum of Art, Charlotte NC, 12 US venues
1989–92 *Craft Today–USA*, Musée des Arts Décoratifs, Paris, France, 14 European venues

SELECTED COLLECTIONS
Arizona State University Art Museum, Tempe, AZ
Mint Museum of Craft & Design, Charlotte, NC
Museum of Art, Rhode Island School of Design, Providence, RI
The Society of Arts and Crafts, Boston, MA
Smithsonian American Art Museum's Renwick Gallery, Washington, DC
Vice-President's Residence, Washington, DC
Virginia Museum of Fine Arts, Richmond, VA
Visual Arts Program, North Carolina State University, Raleigh, NC

AWARDS
2000 North Carolina Artists Fellowships
1995 North Carolina Artists Fellowships
1994 North Carolina Artists Fellowships
1994 National Endowment for the Arts, Visual Artist Fellowship
1988 National Endowment for the Arts, Visual Artist Fellowship

Christopher M. Vance
Born 1967 in Manhatten, NY
Lives in San Francisco, CA

EDUCATION
2001 Candidate for MFA, San Diego State University, San Diego, CA
1992–93 California College of Arts and Crafts, Oakland, CA
1989 BA, Ithaca College, Ithaca, NY

PROFESSIONAL POSITIONS
1999 Summer teaching assistant, Haystack Mountain School of Crafts, Deer Isle, ME
1993–94 Apprentice to Garry Knox Bennett
1993 Fall teaching assistant, Penland School of Crafts, Penland, NC

SELECTED EXHIBITIONS
2000 Tercera Gallery, San Francisco, CA
2000 San Francisco Craft and Folk Art Museum, San Francisco, CA
1999 *California Design 2000*, Contract Design Center, San Francisco, CA
1998 *Form with Function: Contemporary Furniture Design*, Southwestern College, San Diego, CA
1995 Works Gallery, Sonoma, CA
1994 Contract Design Center Show, San Francisco, CA
1993 *Overtime Show*, Hills Plaza, San Francisco, CA
1993 *Clyde Street Show*, Second Street, San Francisco, CA

Gayle Marie Weitz
Born 1956 in Madison, WI
Lives in Boone, NC

EDUCATION
1994 PhD, University of Wisconsin–Madison
1987 MA, University of Wisconsin–Madison

PROFESSIONAL POSITIONS
1992– Associate professor, Appalachian State University, Boone, NC
1990–91 Art teacher, Monona Grove High School, Madison, WI
1986–90 Teaching assistant, University of Wisconsin–Madison

SELECTED EXHIBITIONS
2000 *Twenty-Second Annual Raleigh Fine Arts Society*

Artists Exhibition, Frankie G. Weems Art Gallery, Meredith College, Raleigh, NC

1998–2001 *Celebrating the Creative Spirit: Contemporary Southeastern Furniture*, four US venues

1999 *Gayle Weitz's Sculptural Furniture*, Green Tara Gallery, Carrboro, NC (solo)

1998 *Seventh Biennial: Works in Wood*, Chesterton Art Gallery, Chesterton, IN

1998 *Figurative Furniture by Gayle Marie Weitz*, Artspace, Raleigh, NC (solo)

1998 *Dress Up! Artists Adress Clothing and Self-Adornment*, Charles A. Wustum Museum of Fine Arts, Racine, WI

1997 *The Florida National 1997*, Florida State University Museum of Fine Arts, Tallahassee, FL

1997 *Unusual Furniture by Gayle Marie Weitz*, Rogers Gallery, Berea College, Berea, KY

Wendy M. Wiesner
Born 1966 in Baltimore, MD
Lives in Philadelphia, PA

EDUCATION
1998 BFA, Virginia Commonwealth University, Richmond, VA

PROFESSIONAL POSITIONS
1999– Studio assistant to Jack Larimore

SELECTED EXHIBITIONS
1999 *New Visions*, Philadelphia Furniture Show, Philadelphia, PA

1999 *Virginia Commonwealth University Senior Exhibition*, HAND workshop, Richmond, VA

1999 *Fanciful & Functional*, Hickory Museum of Art, Hickory, NC

1998 Annual Student Show, Anderson Gallery, Virginia Commonwealth University, Richmond, VA

SELECTED COLLECTIONS
William Hammersly

AWARDS
1998 Dean's awards

Brian Wilson
Born 1964 in Minneapolis, MN
Lives in San Francisco, CA

EDUCATION
1992 MFA, San Diego State University, San Diego, CA
1985 BA, San Diego State University, San Diego, CA
AA, Colorado Institute of Art, Denver, CO

PROFESSIONAL POSITIONS
1995– Studio artist
1990–95 Teaching assistant, associate, instructor, San Diego State University, San Diego, CA
1987–88 Art director, Arnold Buck Advertising, San Diego, CA
1986–87 Graphic design consultant, Denver, CO

SELECTED EXHIBITIONS
2000 Anderson Ranch Gallery, Snowmass Village, CO
1999 *West Coast Furniture*, Oceanside Museum, Oceanside, CA
1998 *SDSU Furniture*, The Society of Arts and Crafts, Boston, MA
1998 *Cool Stuff*, San Jose Museum of Art, San Jose, CA
1997 *Narratives in Wood*, Virginia Breier Gallery, San Francisco, CA
1997 Opening Exhibition, Melting Point Gallery, San Francisco, CA
1996 *Objects of Desire*, Tecerra Gallery, Los Gatos, CA
1995 MFA Thesis Exhibition, San Diego, CA
1993 *New Art Forms*, *Anticipations '93*, Group Show, Chicago, IL
1992 *Black and White*, Tecerra Gallery, Los Gatos, CA

SELECTED COLLECTIONS
Gary Cooper, San Diego, CA
Charles Dishman, New York, NY
Donald Earlenbaugh, San Francisco, CA
Robin Williams, San Francisco, CA

AWARDS
1995 Paul Lingrum Scholarship
1993 Anticipations '93, Chicago, IL
1986 Denver Art Director's Club, Denver, CO
1985 Denver Art Director's Club, Denver, CO

Edward Zucca

Born 1946 in Philadelphia, PA
Lives in Woodstock, CT

EDUCATION
1968 BFA, Philadelphia College of Art, Philadelphia, PA

PROFESSIONAL POSITIONS
1974– Self-employed furniture designer and manufacturer, Woodstock, CT
1972 Faculty, Rhode Island School of Design, Providence, RI
1969–71 Artist in residence, Penland School of Crafts, Penland, NC

SELECTED EXHIBITIONS
1997 *Survey of North American Contemporary Furniture*, Neuberger Museum of Art, State University of New York, Purchase, NY
1996 *Contemporary Lights: Channukah Menorahs*, Margolis Gallery, Houston, TX
1996 *Edward Zucca: New Work*, Peter Joseph Gallery, New York, NY (solo)
1995 *Child's Play: Furniture for Children*, Lyman Allyn Museum of Art at Connecticut College, New London, CT
1995 *Connecticut Contemporary Woodworking*, The Silo Gallery, New Milford, CT
1994 *Dialogues: On and Off the Wall*, Peter Joseph Gallery, Schmidt Bingham Gallery, Clark Gallery, New York, NY

1993 *Conservation by Design*, Museum of Art, Rhode Island School of Design, Providence, RI
1990 *American Studio Furniture: The New England Contingent*, The Society of Arts and Crafts, Boston, MA
1986 *Craft Today: Poetry of the Physical*, American Craft Museum, New York, NY
1983 *Ornamentalism: The New Decorativeness in Architecture and Design*, The Hudson River Museum, Yonkers, NY

SELECTED COLLECTIONS
Ronald and Anne Abramson
Arc International, The Gallery of Applied Arts
Stanley and Iris Ashkinos
Best Products Corporate Collection
Connecticut Commission on the Arts Permanent Collection
Museum of Fine Arts, Boston, MA
Franklin and Suzy Parrasch
U.S. News and World Report Corporate Collection

AWARDS
1989 Connecticut Commission on the Arts, Individual Artist Grant
1984 National Endowment for the Arts, Art in Architecture Commission, Doors for Federal Courthouse Restoration, New Haven, CT
1981 National Endowment for the Arts, Craftsman's Fellowship Grant
1979 Connecticut Commission on the Arts, Individual Artist Grant

Index of Furnituremakers

(bold page number indicates image)

Designed by David Alcorn,
Alcorn Publication Design, Graeagle, California

Editied by Patricia Powell, Elvehjem Museum of Art

The body type is Bauer Bodoni, set in its normal, bold, and italic
forms. The title and headlines are set in Helvetica Thin.

The cover and text stocks are Centura Dull